DYSFUNCTIONAL FITNESS

A COLORING BOOK FOR PEOPLE WHO ARE OBSESSED WITH FITNESS
BY KEITH STONE

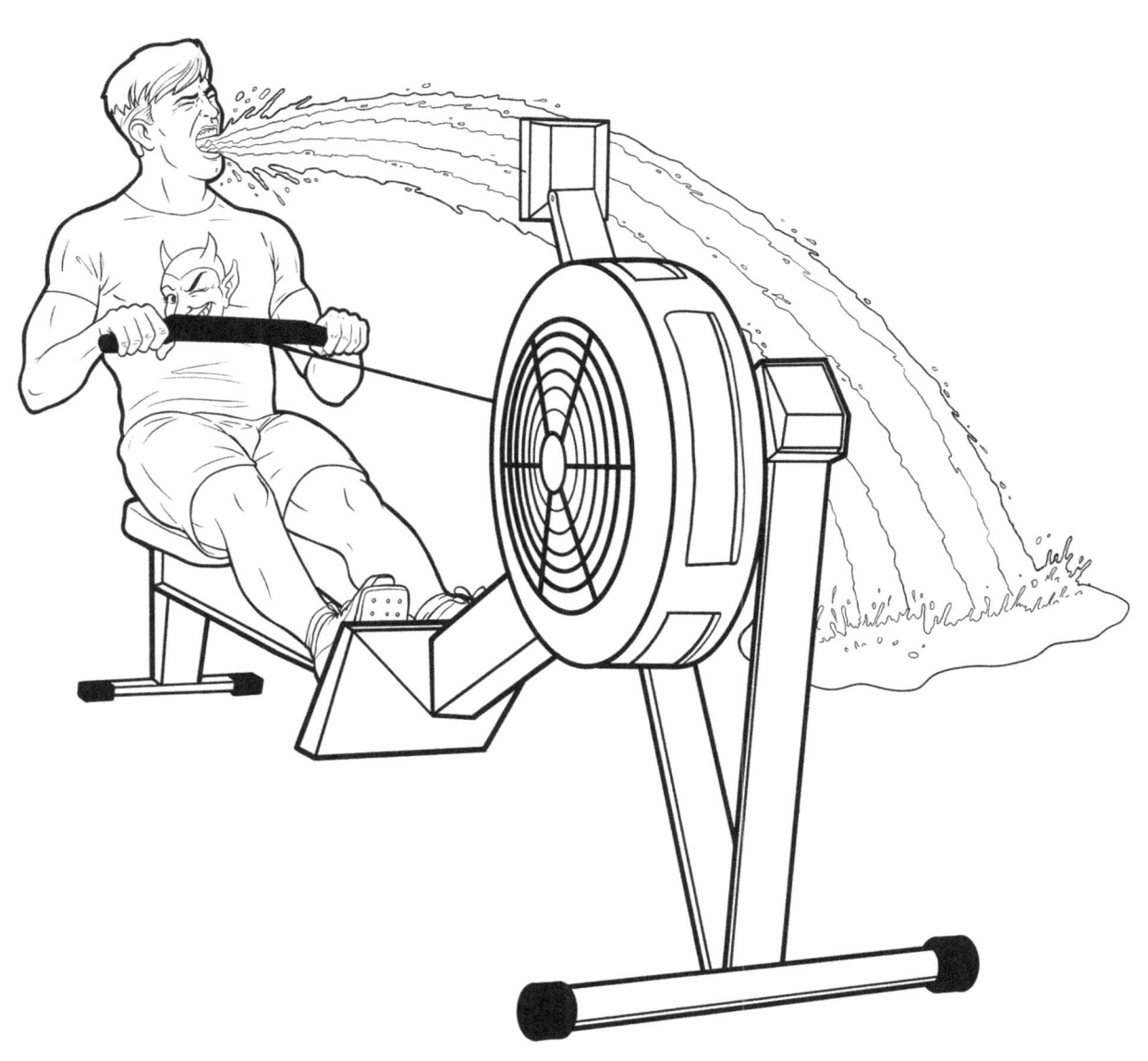

Copyrights 2019 Keith Stone. All artwork is property of the author and may not be reused or duplicated without express written permission from the owner

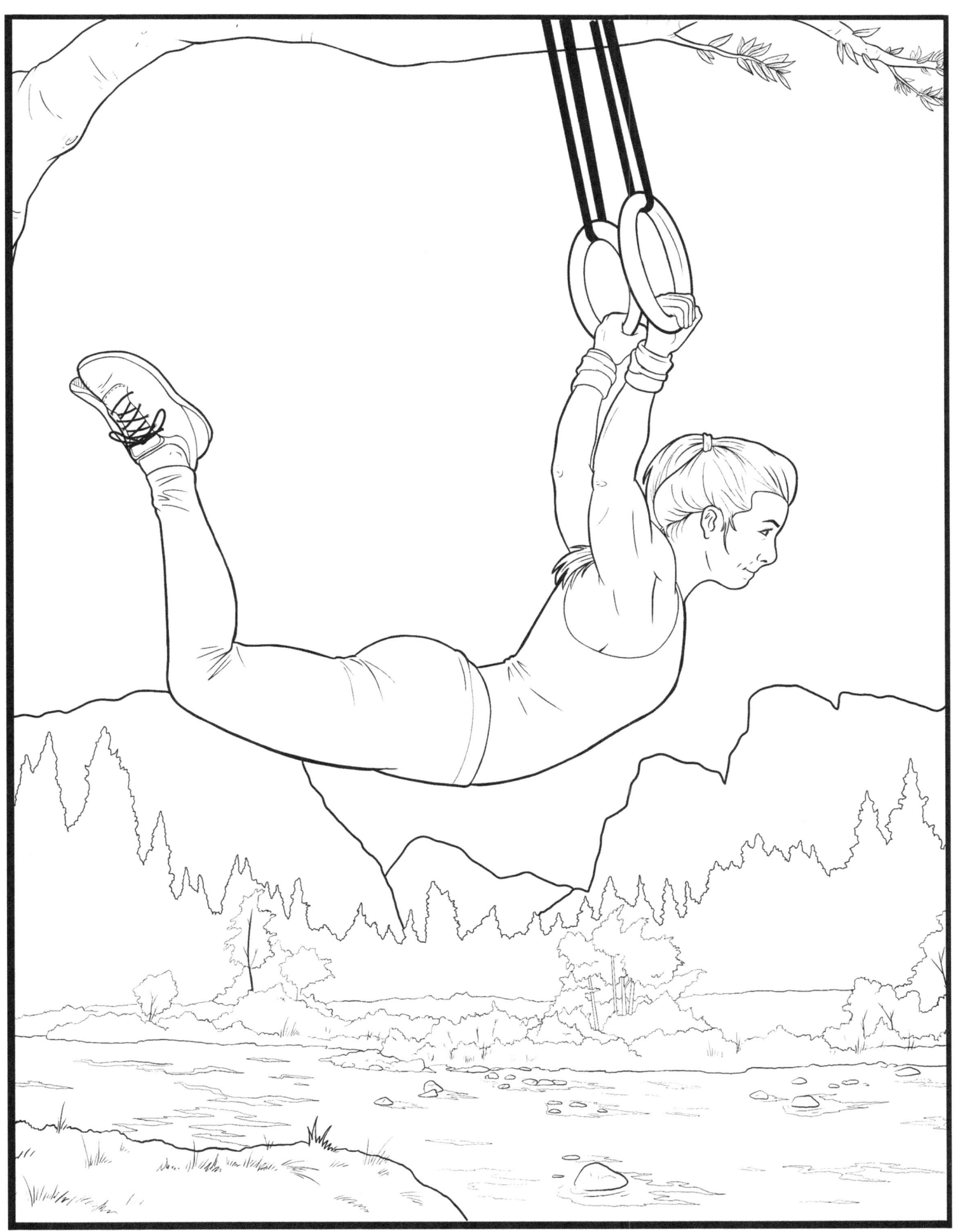

Copyrights 2019 Keith Stone. All artwork is property of the author and may not be reused or duplicated without express written permission from the owner

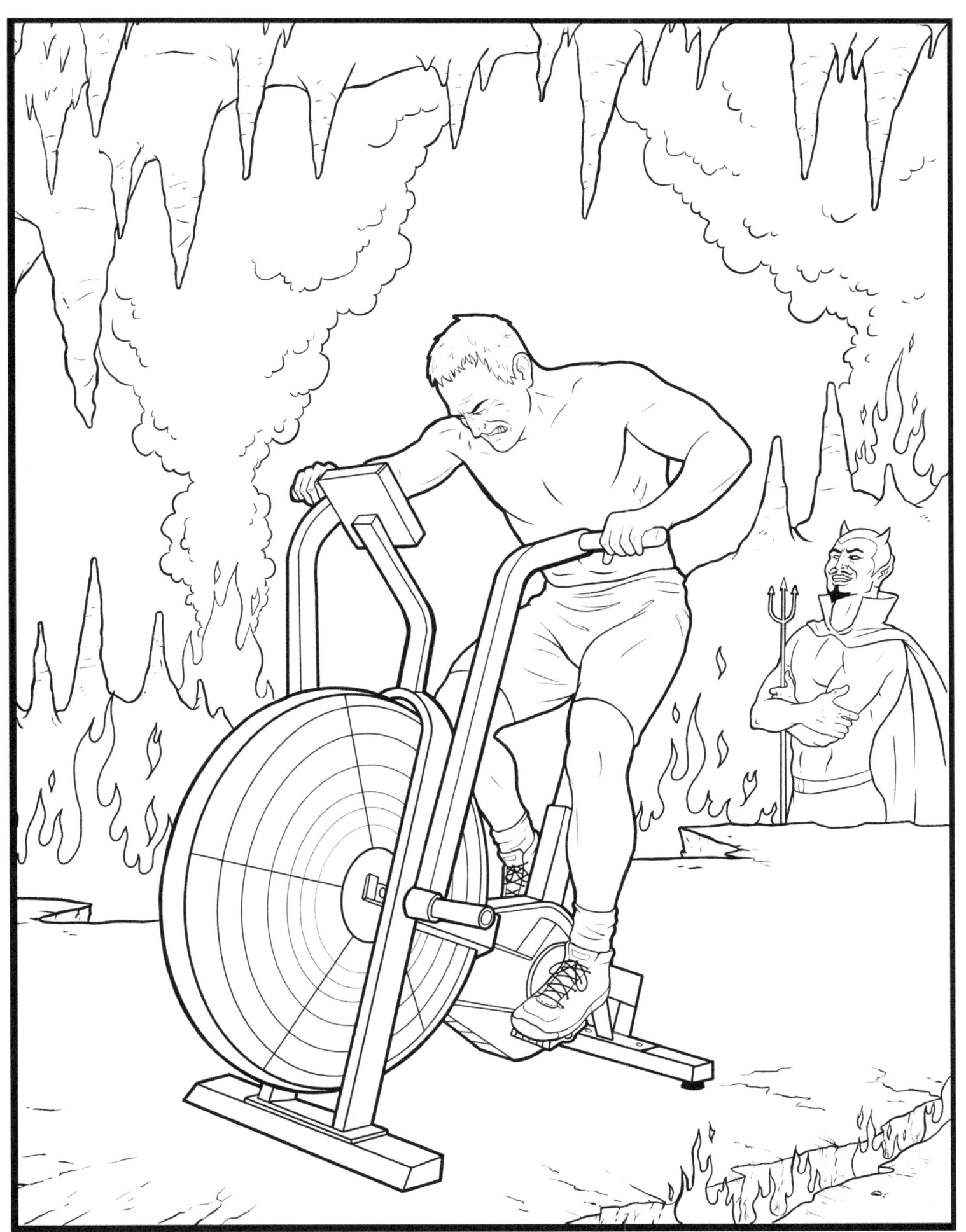

Copyrights 2019 Keith Stone. All artwork is property of the author and may not be reused or duplicated without express written permission from the owner

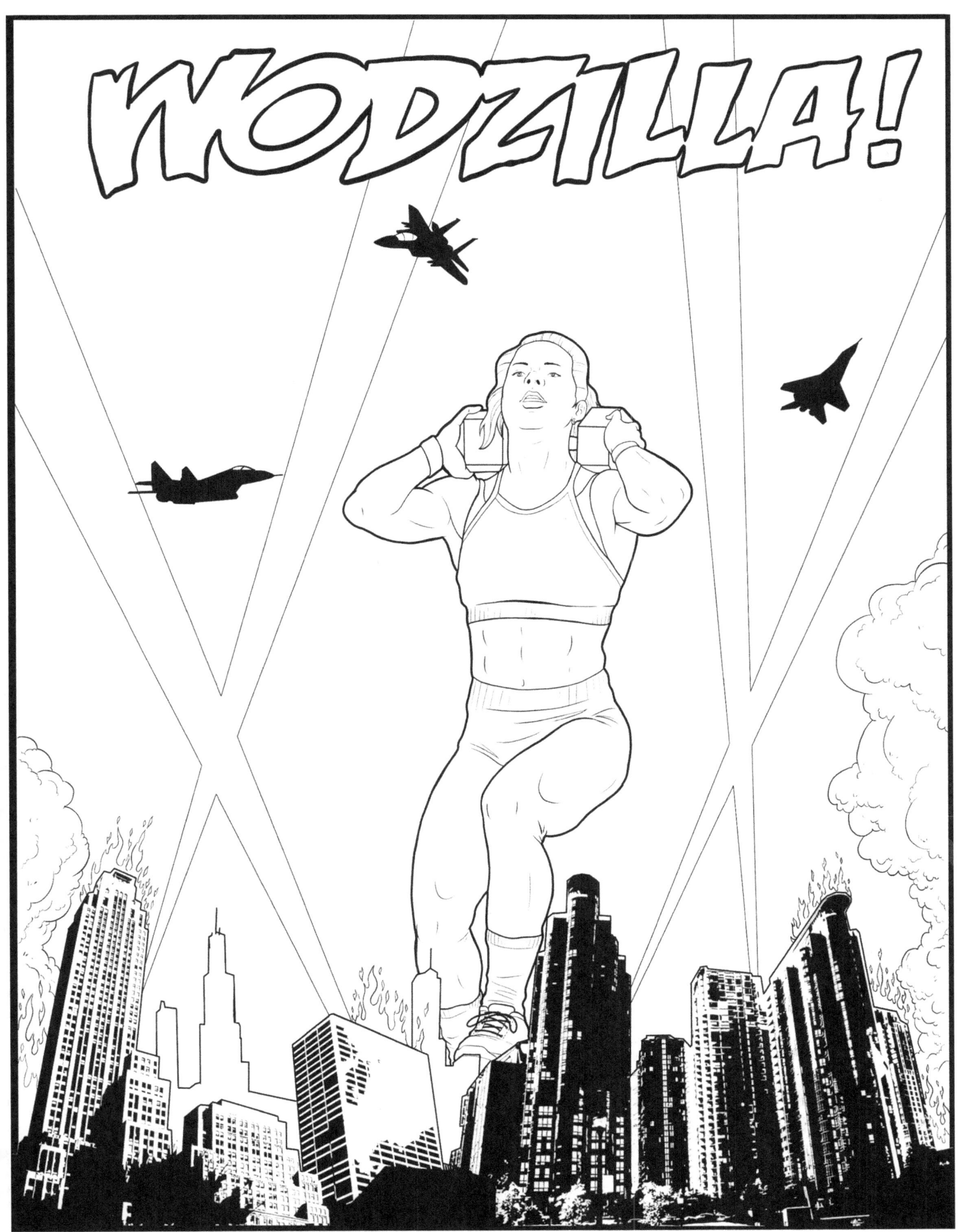

Copyrights 2019 Keith Stone. All artwork is property of the author and may not be reused or duplicated without express written permission from the owner

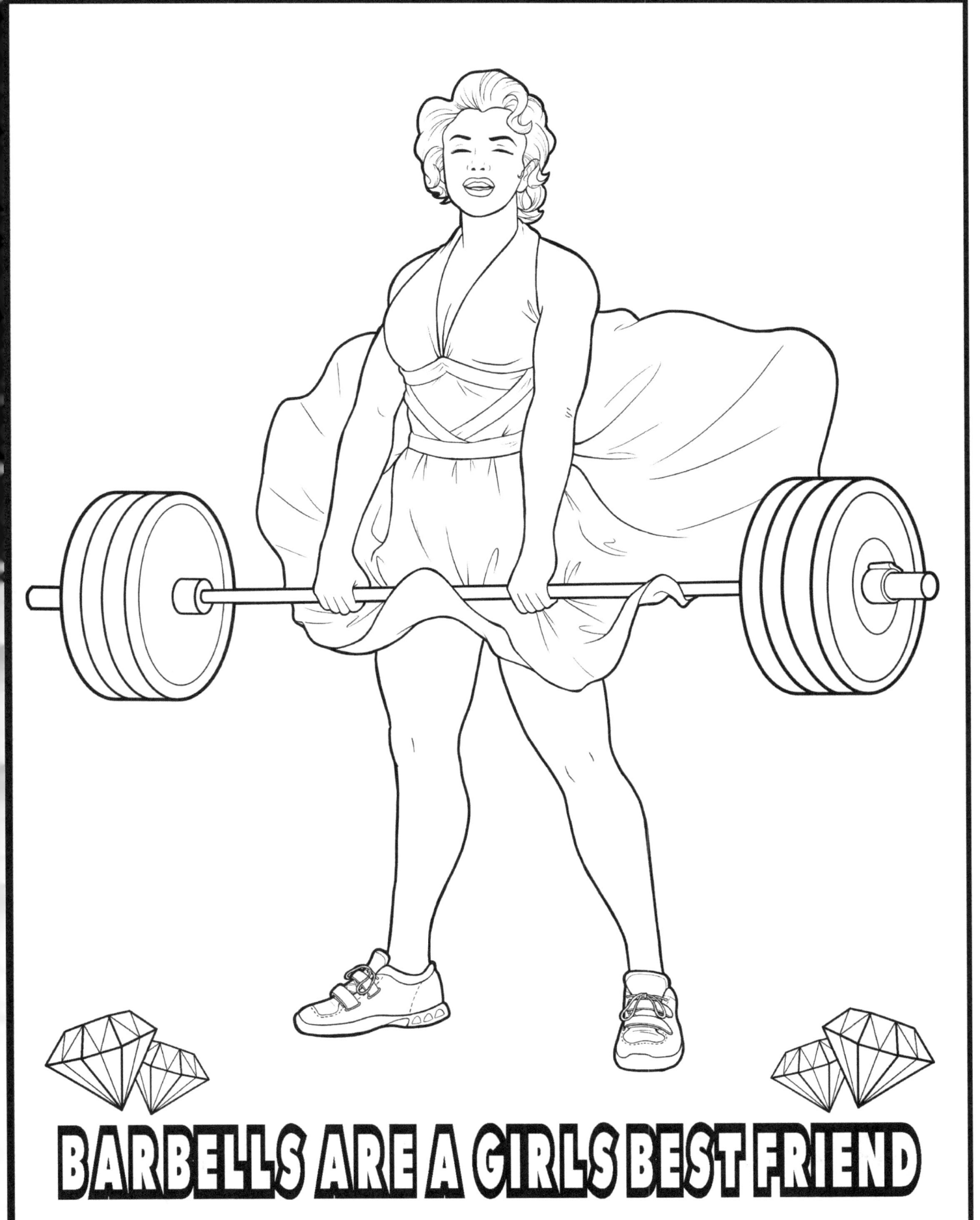

Copyrights 2019 Keith Stone. All artwork is property of the author and may not be reused or duplicated without express written permission from the owner

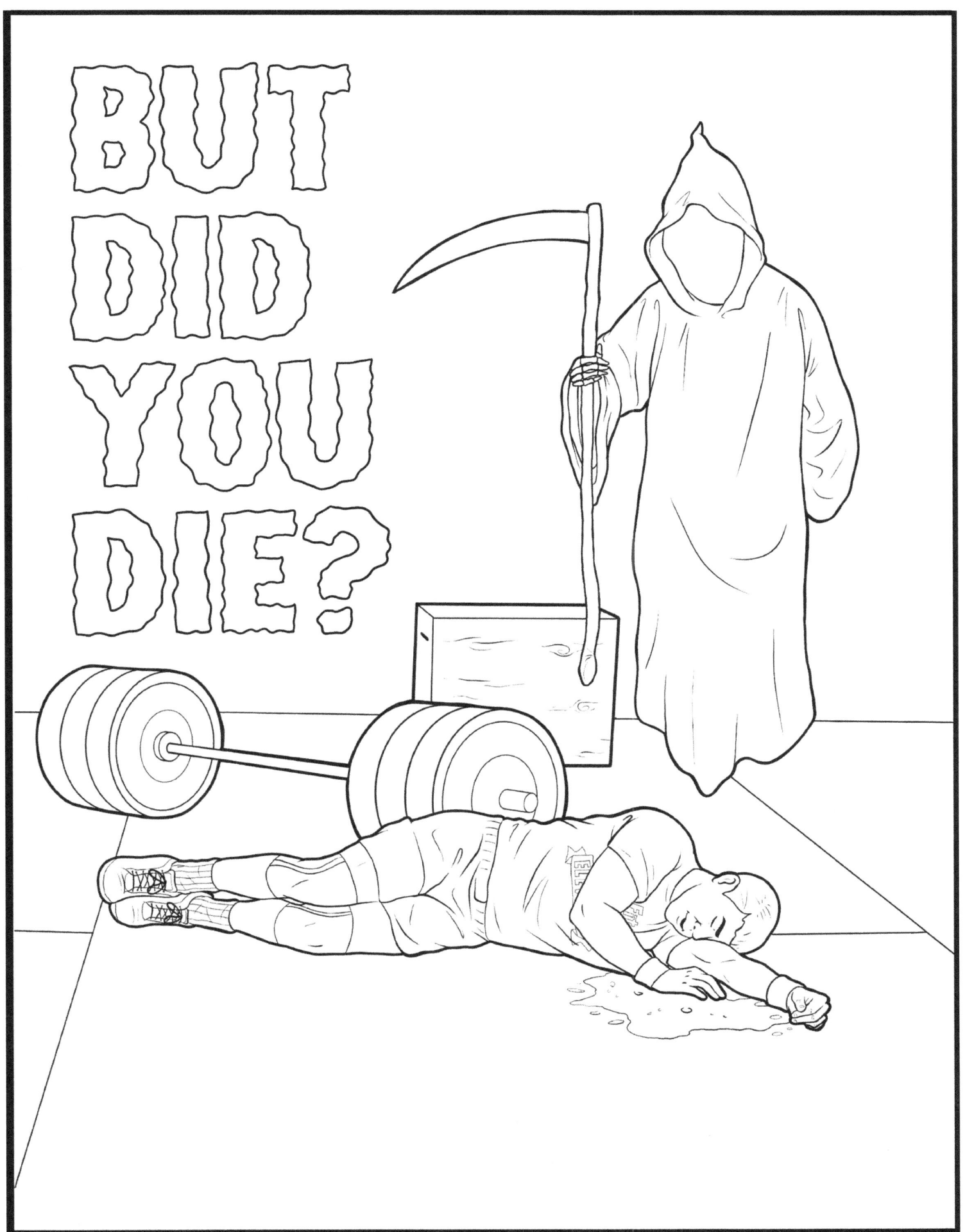

Copyrights 2019 Keith Stone. All artwork is property of the author and may not be reused or duplicated without express written permission from the owner

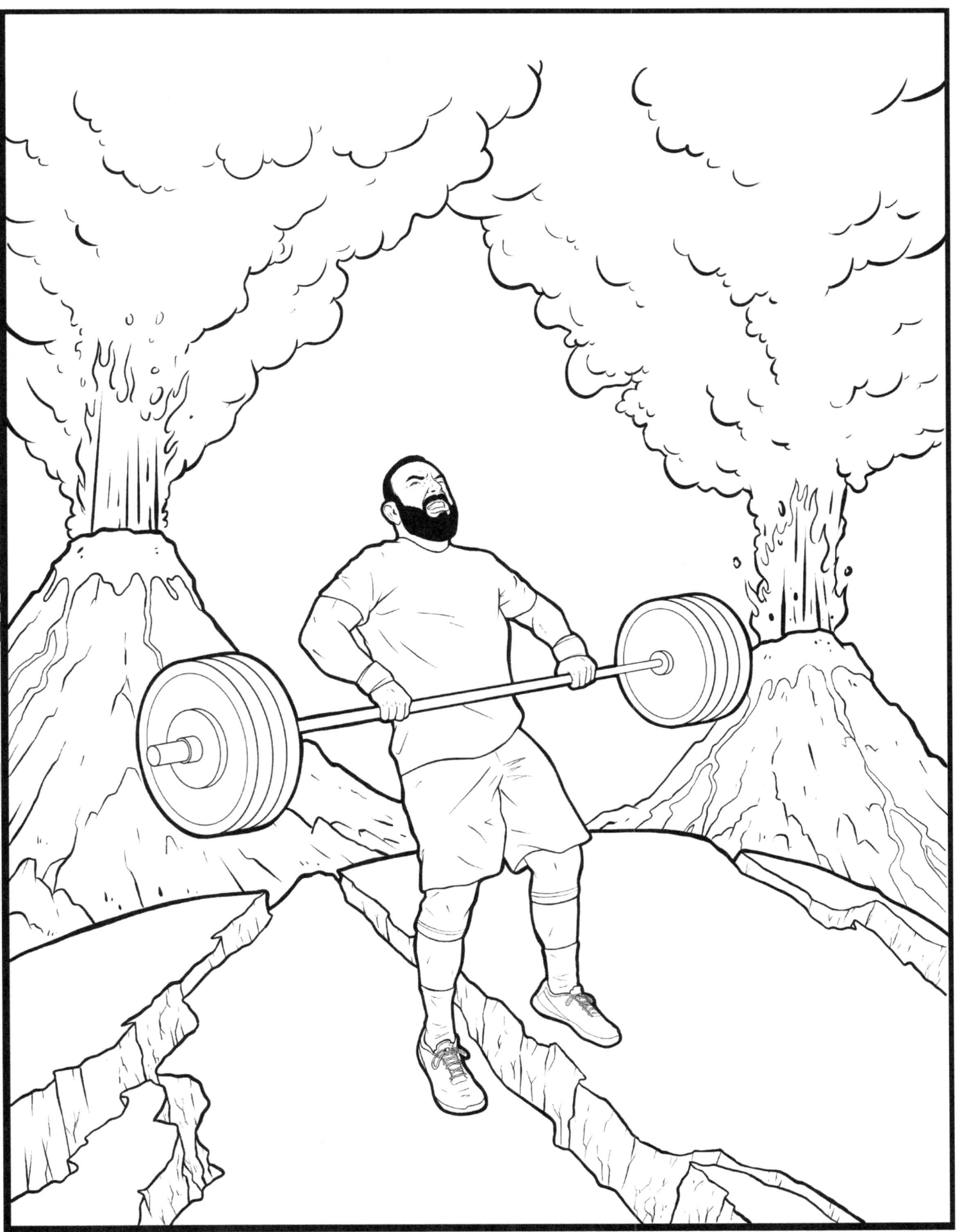

Copyrights 2019 Keith Stone. All artwork is property of the author and may not be reused or duplicated without express written permission from the owner

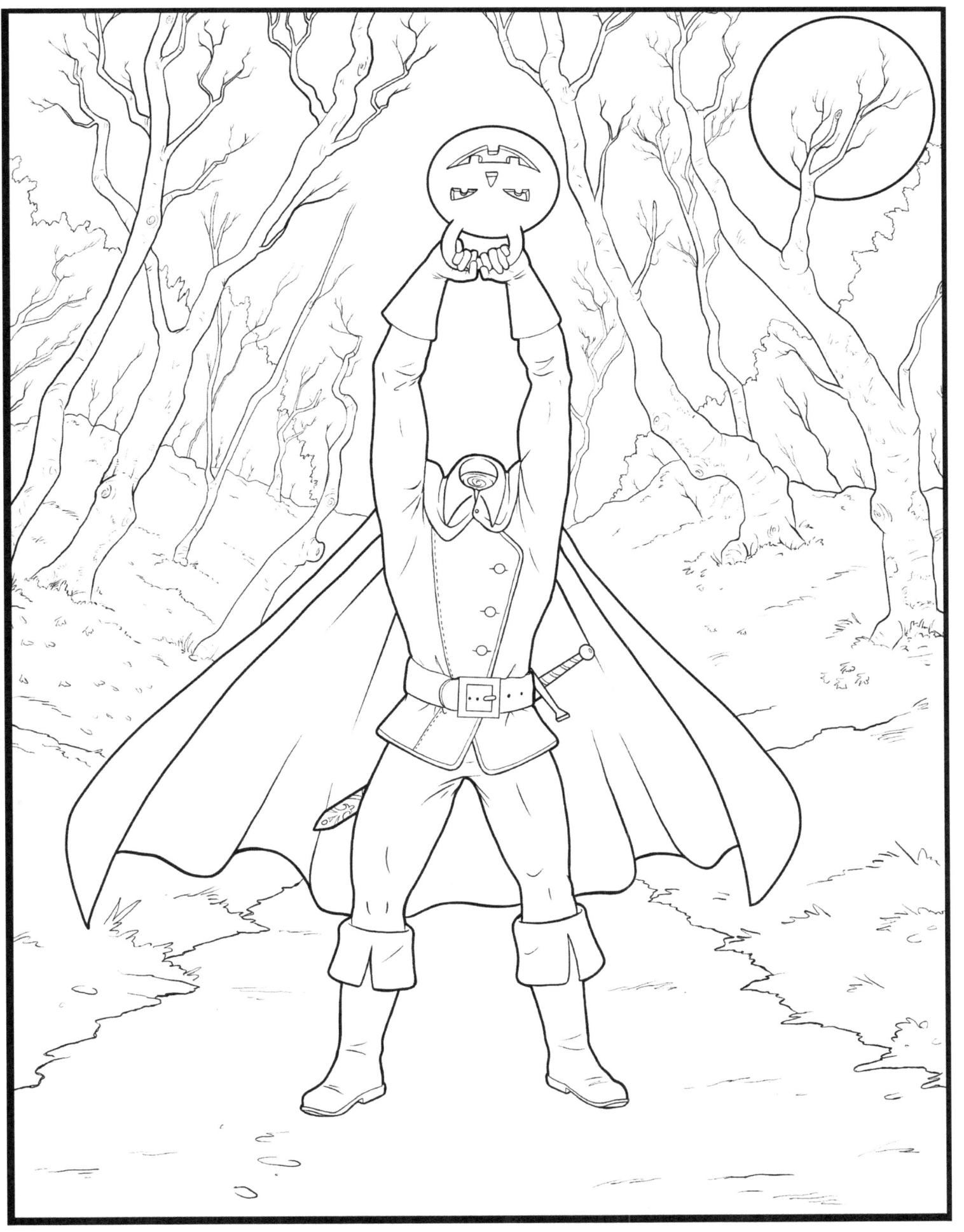

Copyrights 2019 Keith Stone. All artwork is property of the author and may not be reused or duplicated without express written permission from the owner

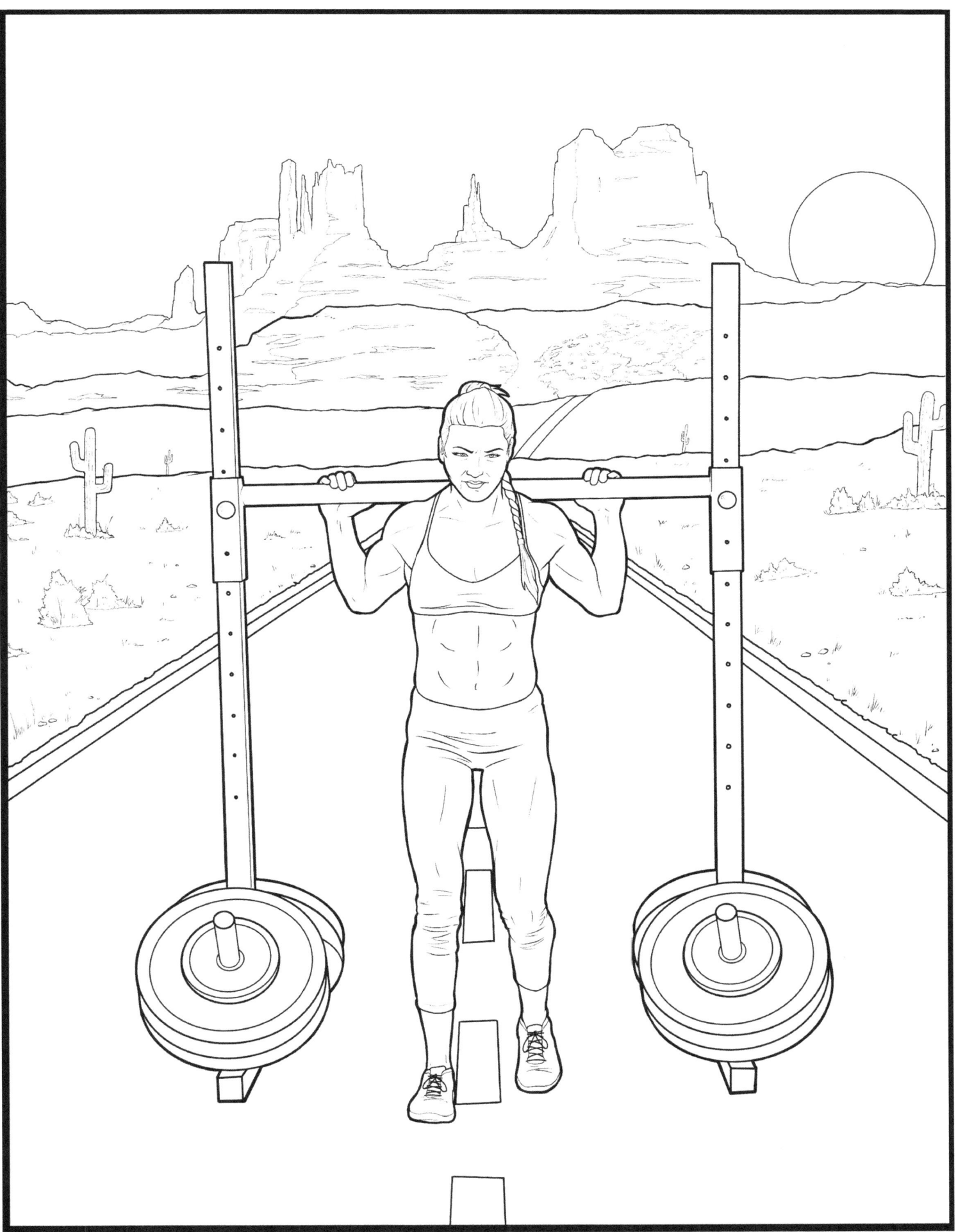

Copyrights 2019 Keith Stone. All artwork is property of the author and may not be reused or duplicated without express written permission from the owner

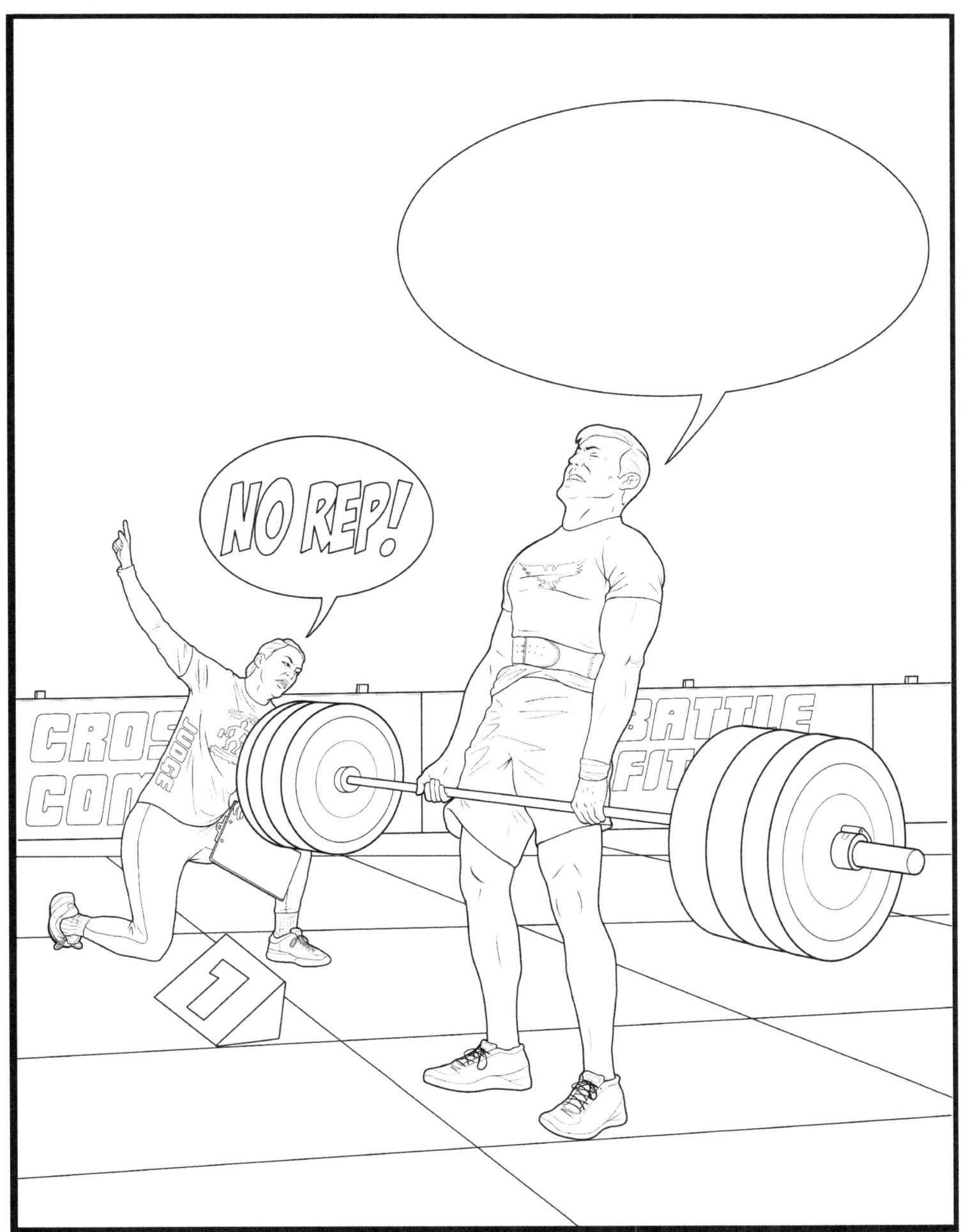

Copyrights 2019 Keith Stone. All artwork is property of the author and may not be reused or duplicated without express written permission from the owner

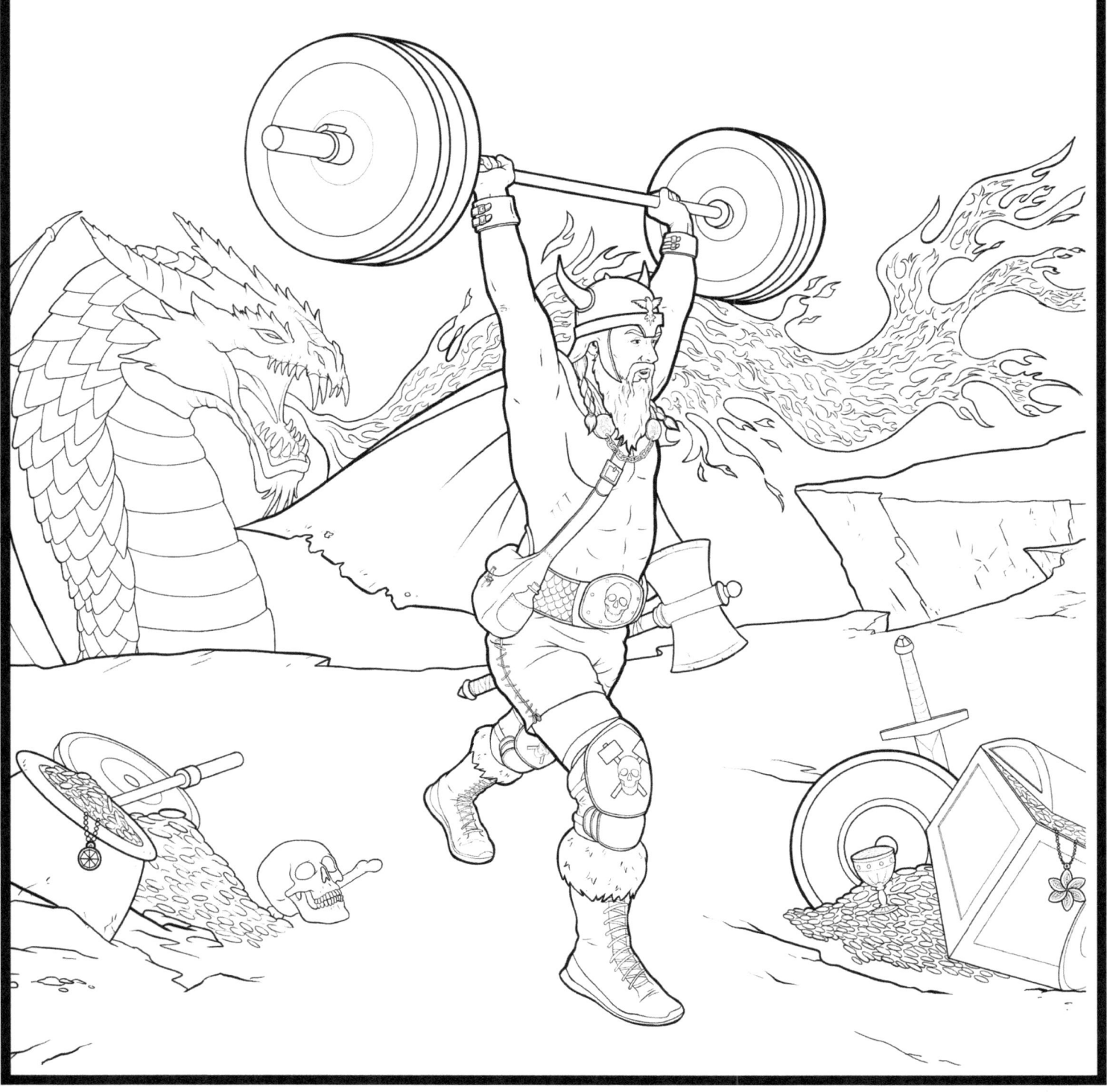

Copyrights 2019 Keith Stone. All artwork is property of the author and may not be reused or duplicated without express written permission from the owner

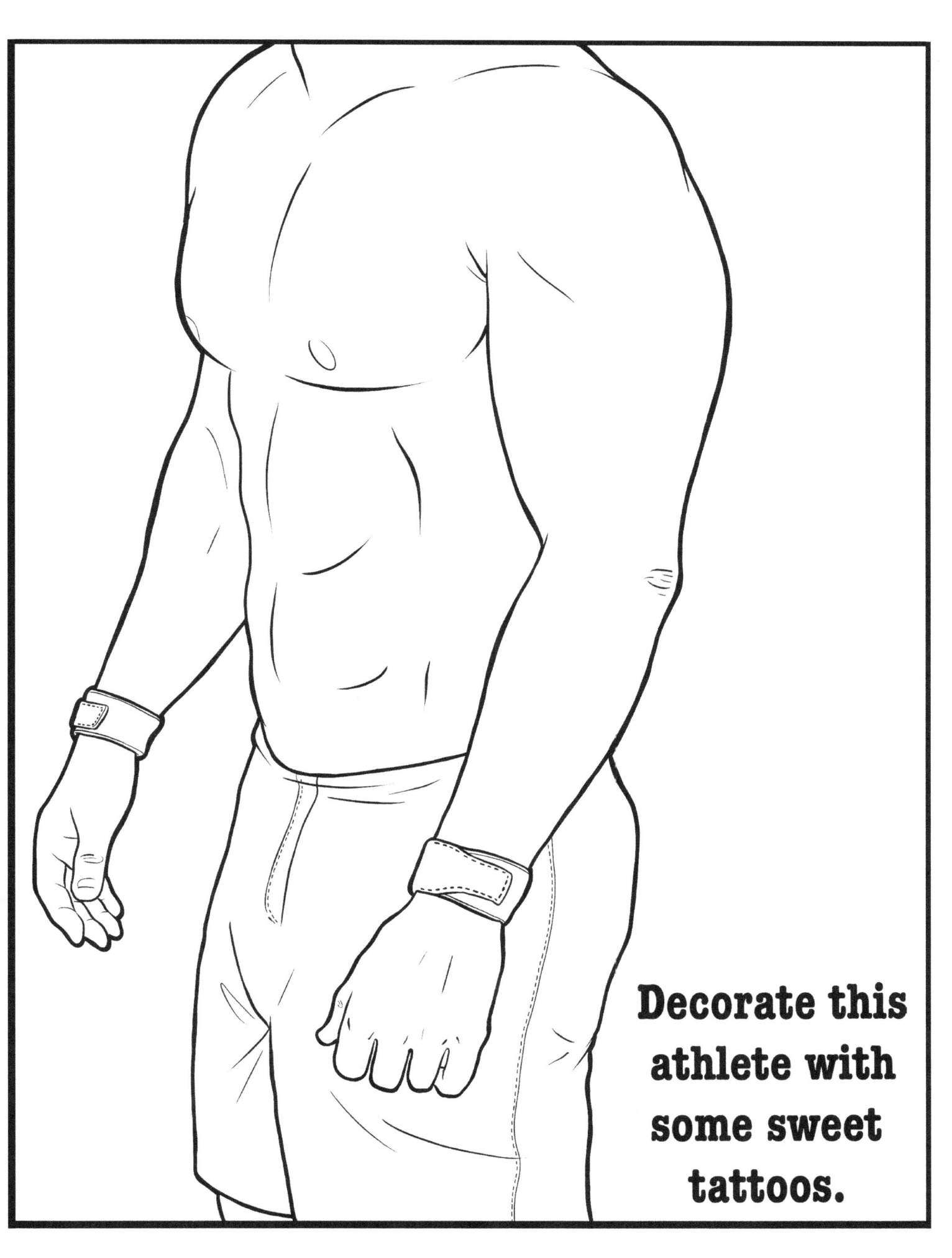

Copyrights 2019 Keith Stone. All artwork is property of the author and may not be reused or duplicated without express written permission from the owner

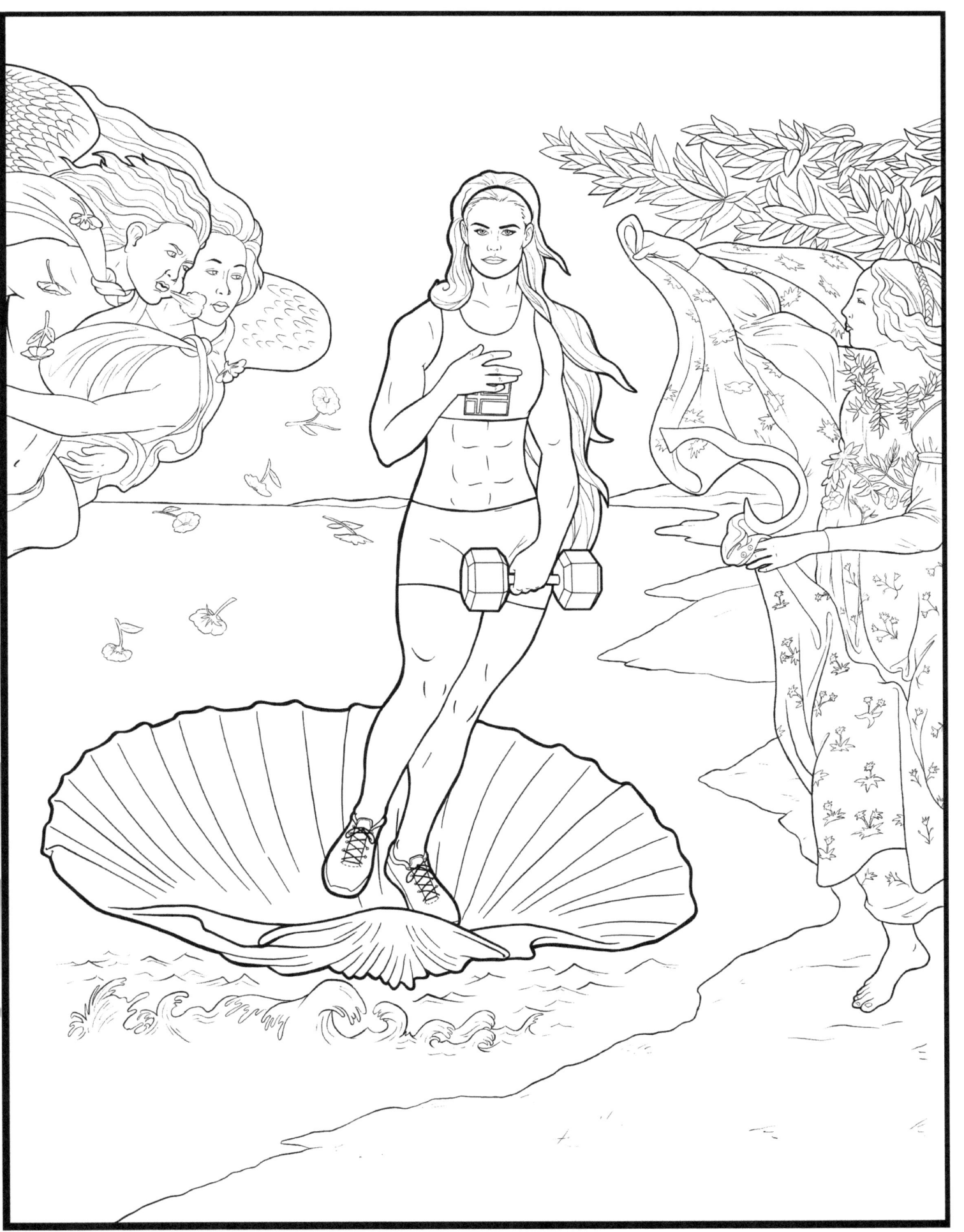

Copyrights 2019 Keith Stone. All artwork is property of the author and may not be reused or duplicated without express written permission from the owner

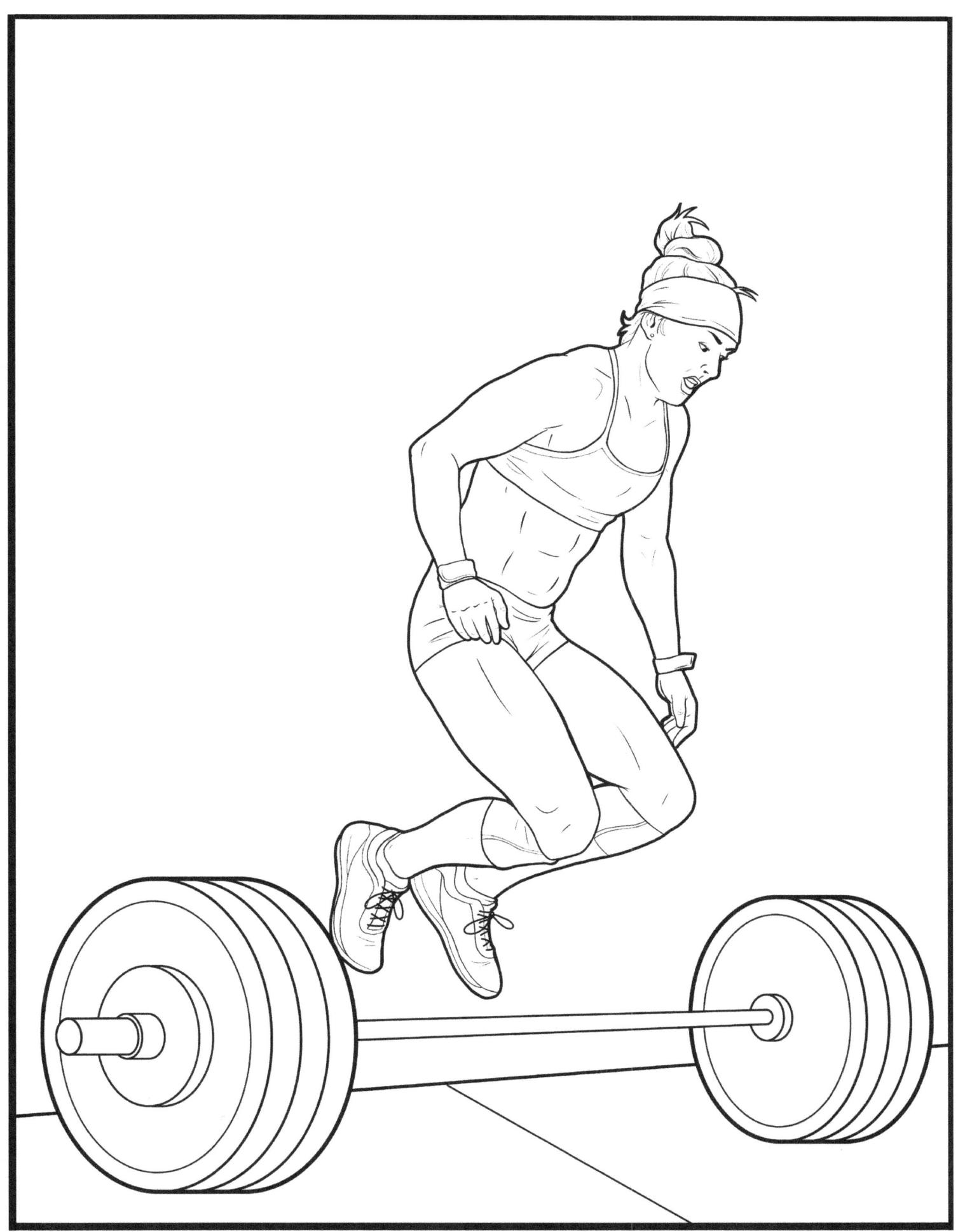

Copyrights 2019 Keith Stone. All artwork is property of the author and may not be reused or duplicated without express written permission from the owner

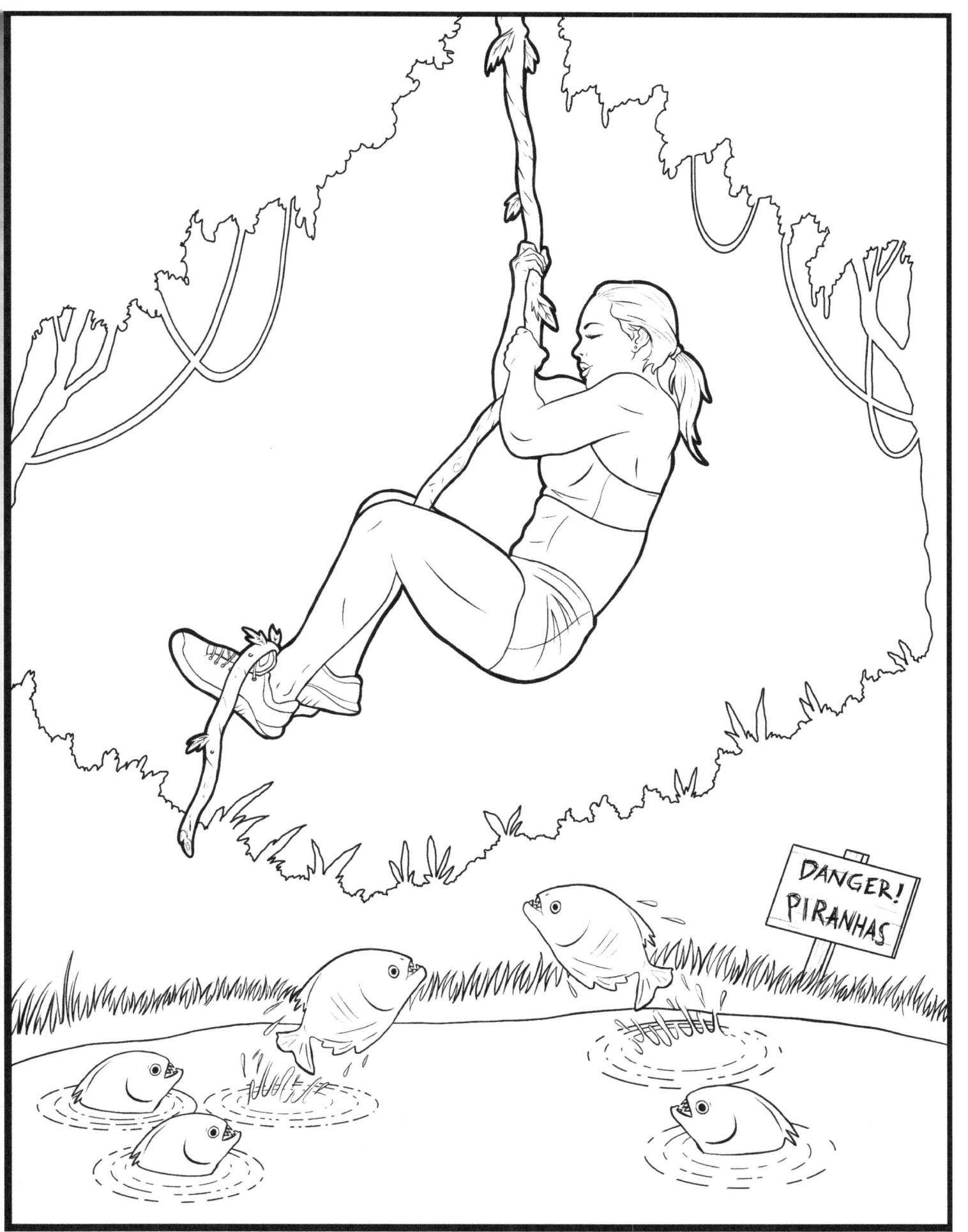

Copyrights 2019 Keith Stone. All artwork is property of the author and may not be reused or duplicated without express written permission from the owner

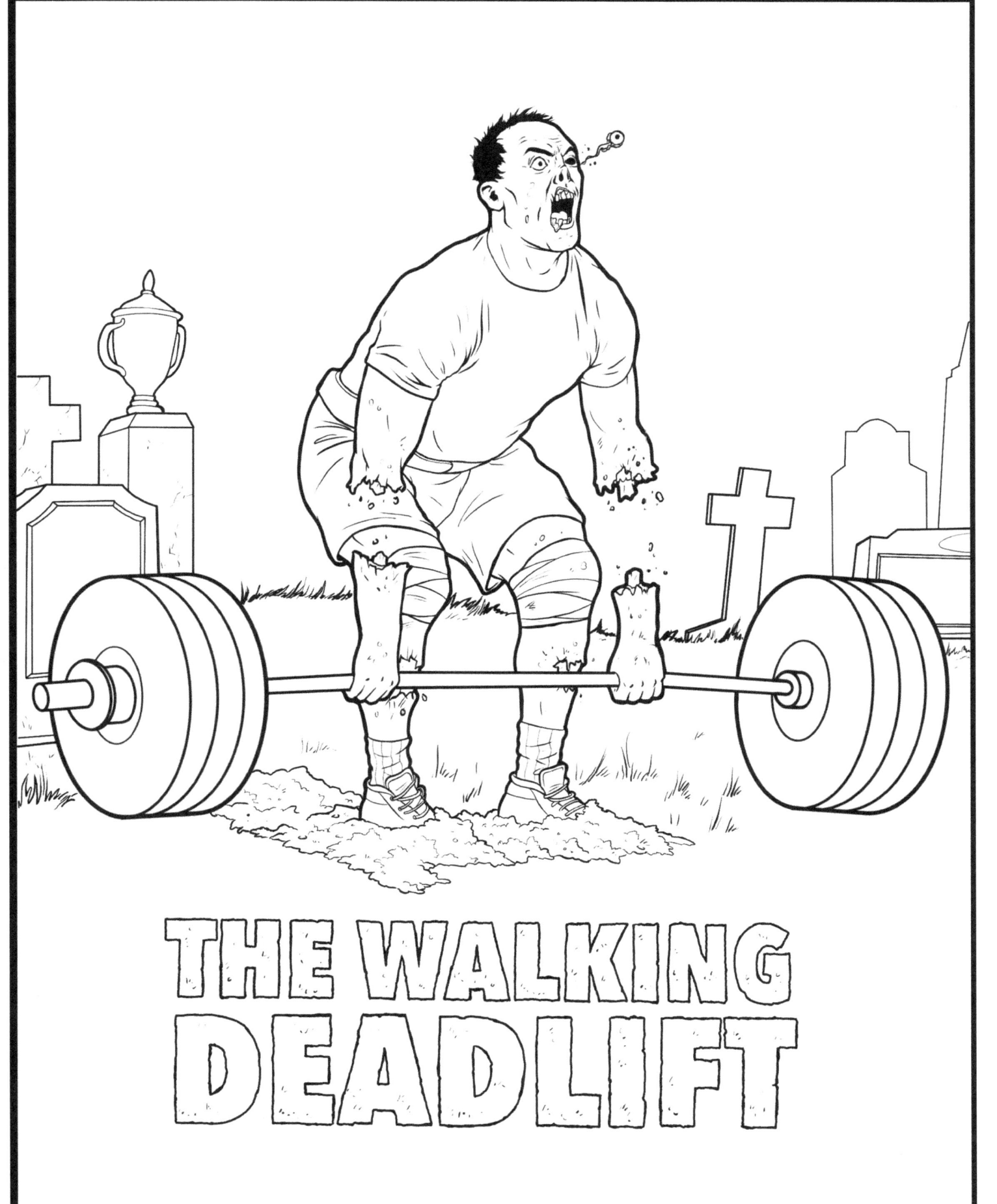

Copyrights 2019 Keith Stone. All artwork is property of the author and may not be reused or duplicated without express written permission from the owner

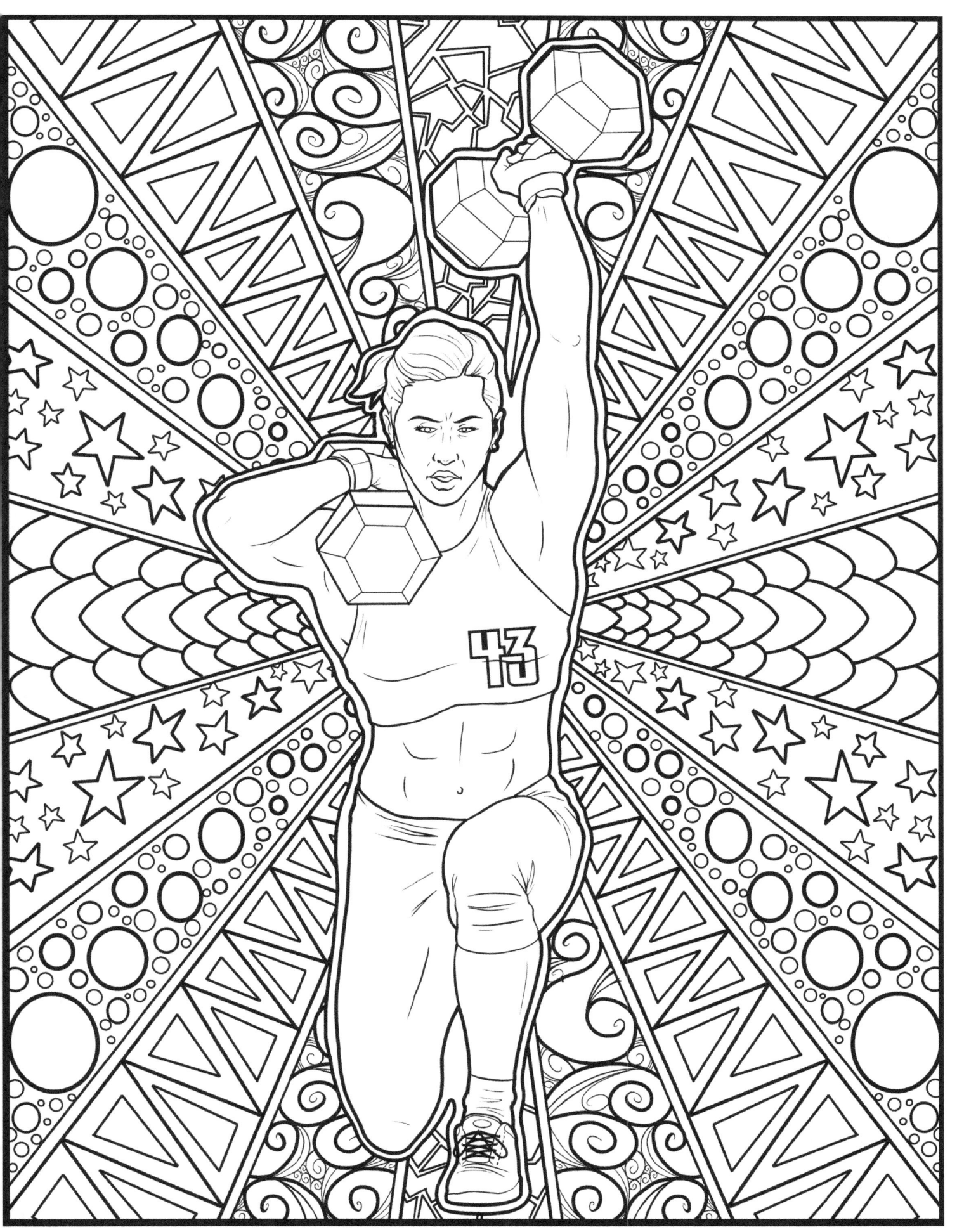

Copyrights 2019 Keith Stone. All artwork is property of the author and may not be reused or duplicated without express written permission from the owner

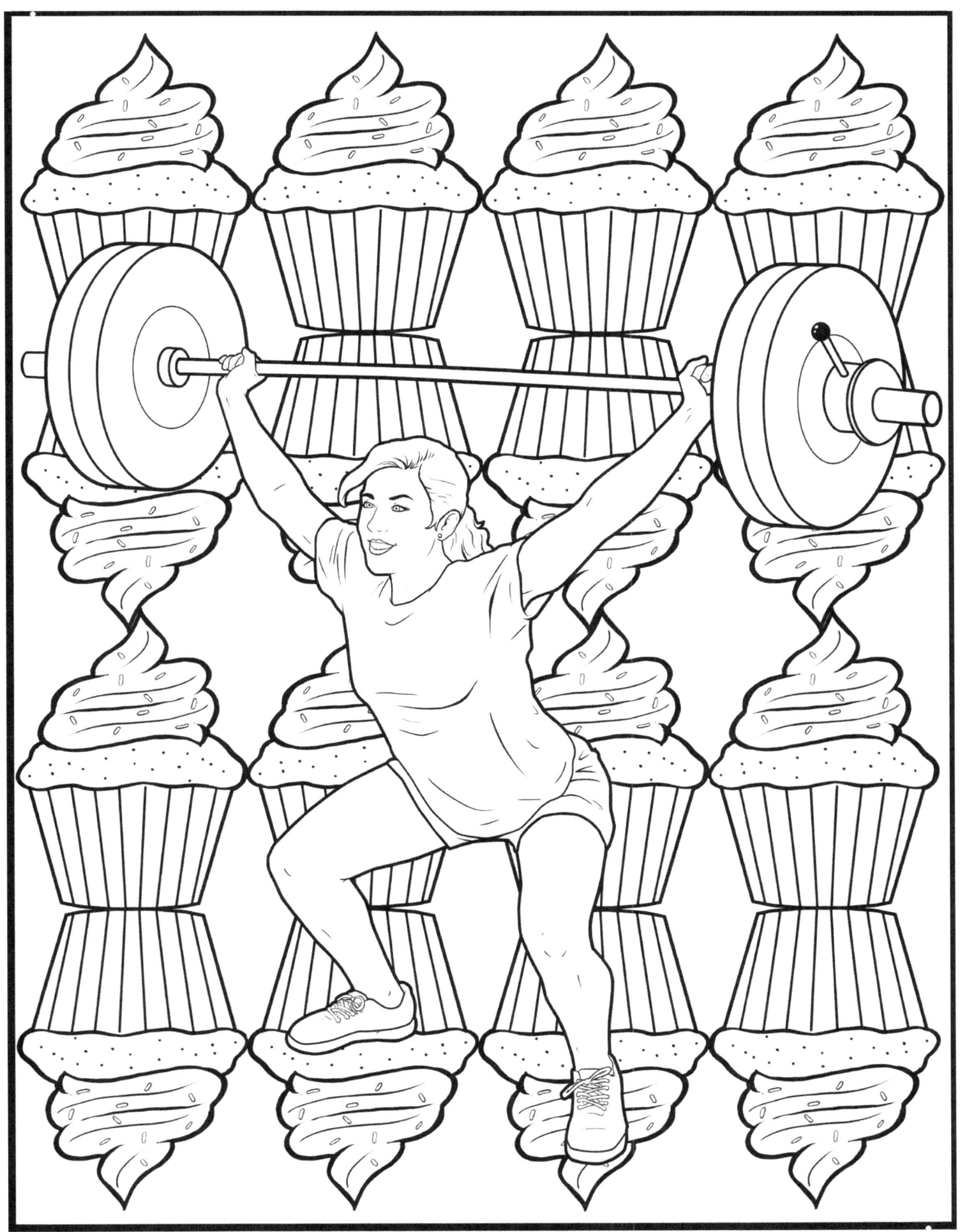

Copyrights 2019 Keith Stone. All artwork is property of the author and may not be reused or duplicated without express written permission from the owner

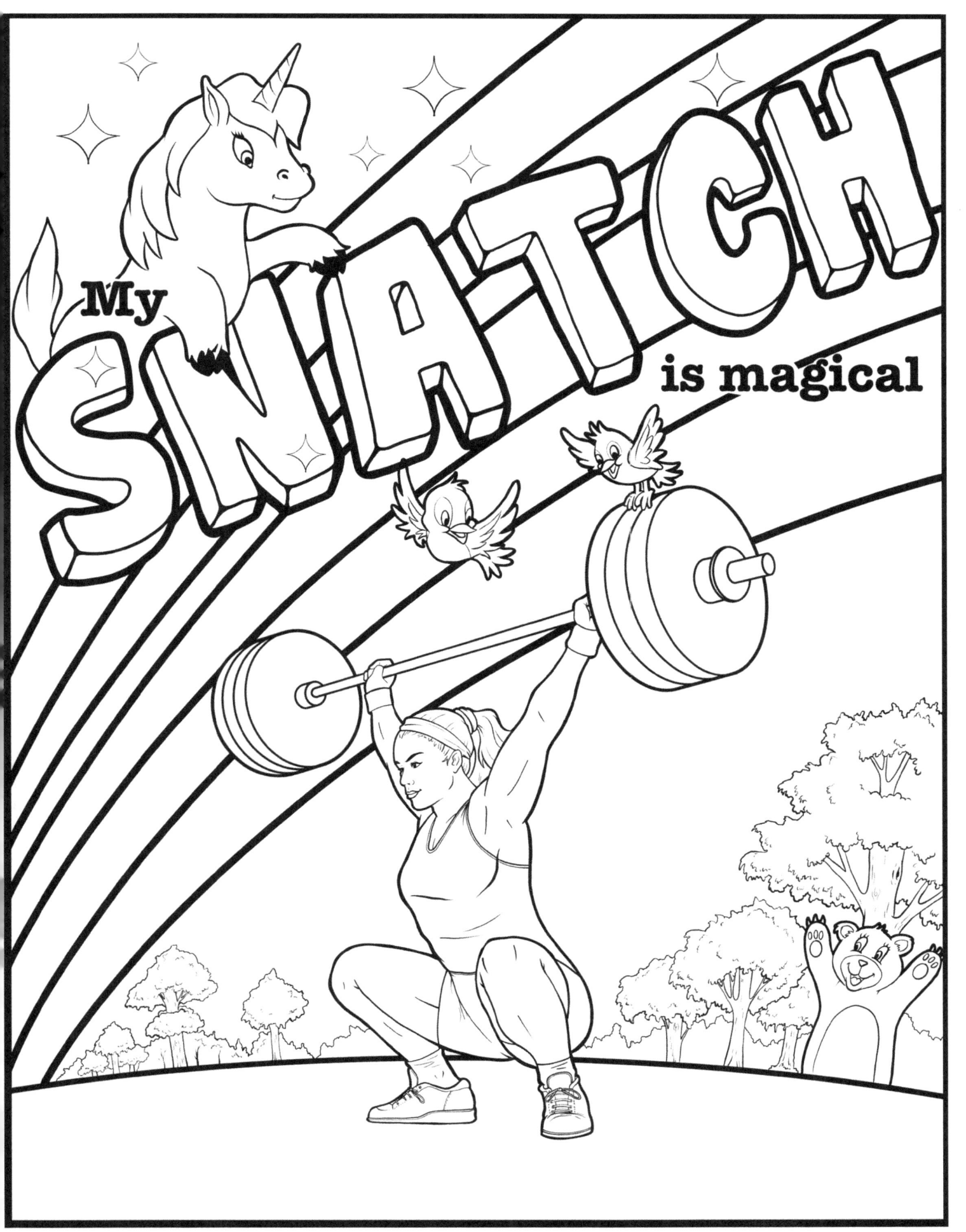

Copyrights 2019 Keith Stone. All artwork is property of the author and may not be reused or duplicated without express written permission from the owner

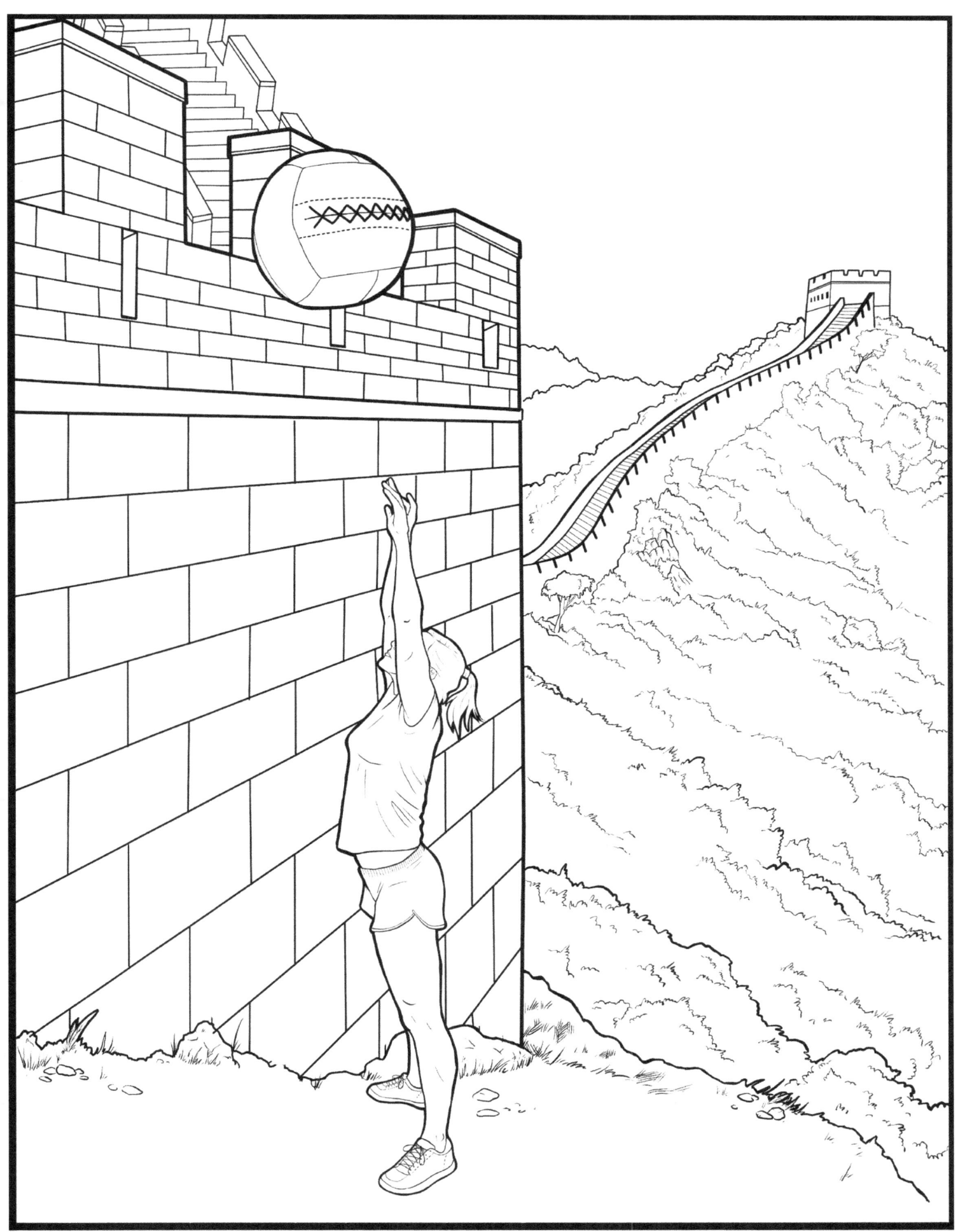

Copyrights 2019 Keith Stone. All artwork is property of the author and may not be reused or duplicated without express written permission from the owner

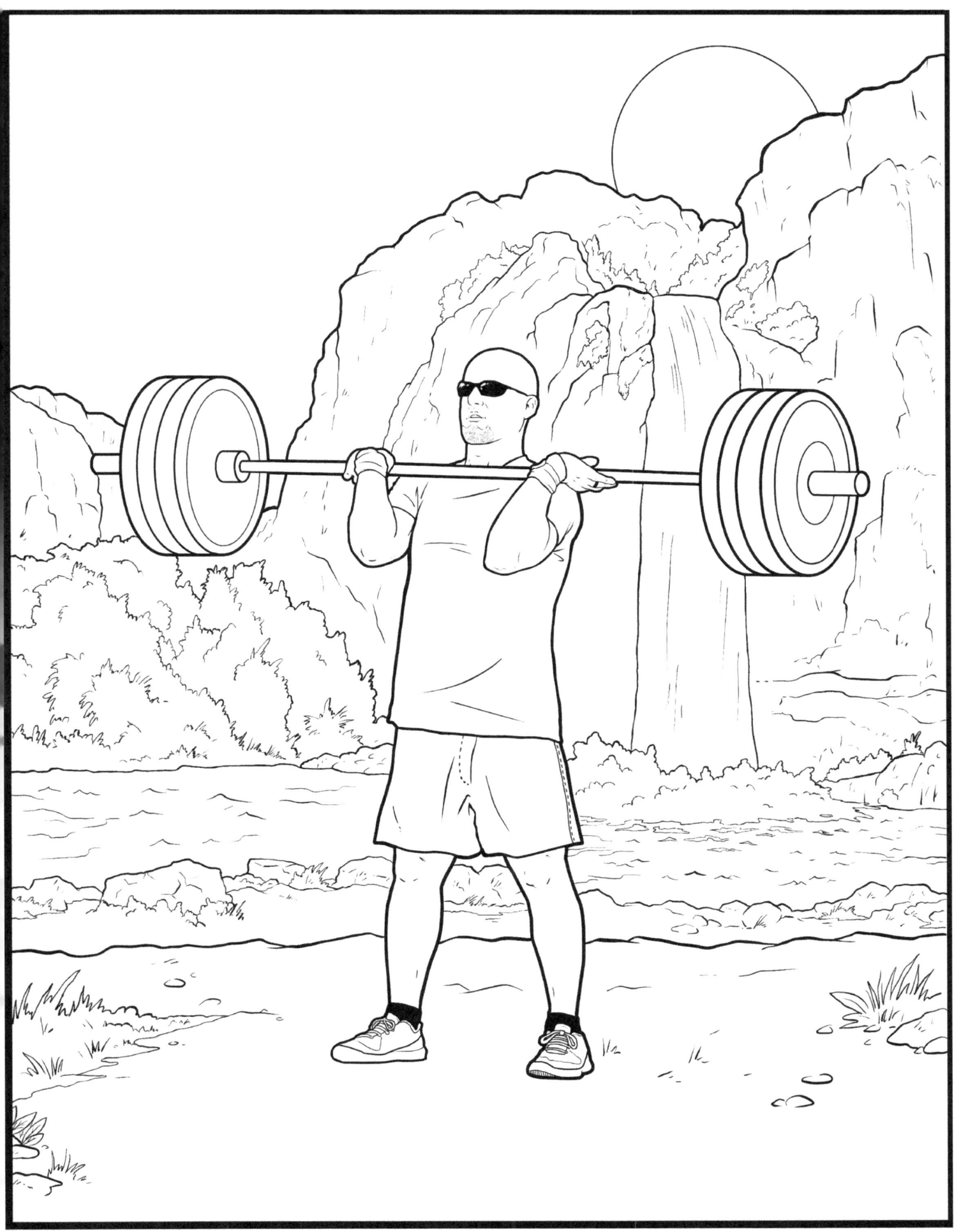

Copyrights 2019 Keith Stone. All artwork is property of the author and may not be reused or duplicated without express written permission from the owner

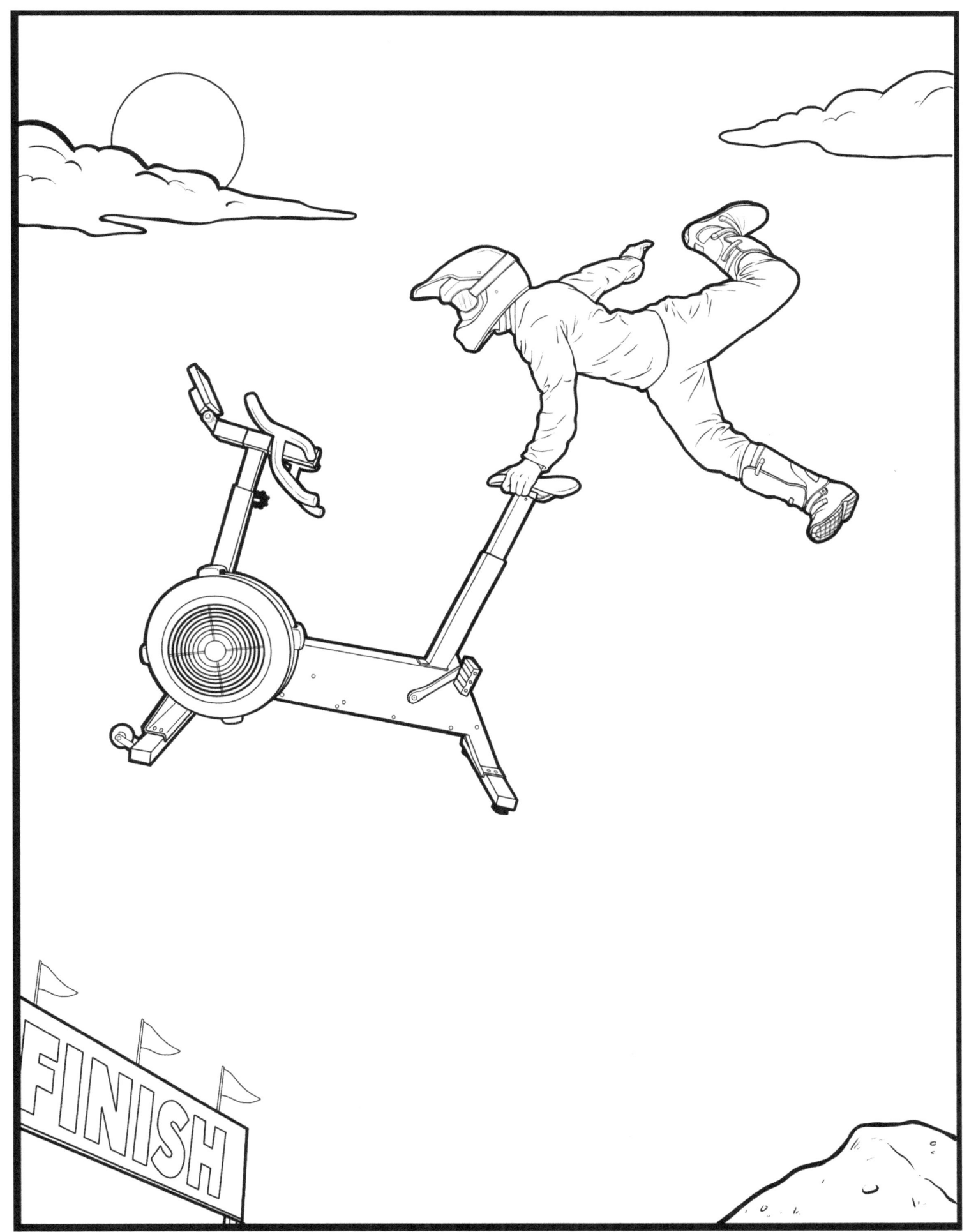

Copyrights 2019 Keith Stone. All artwork is property of the author and may not be reused or duplicated without express written permission from the owner

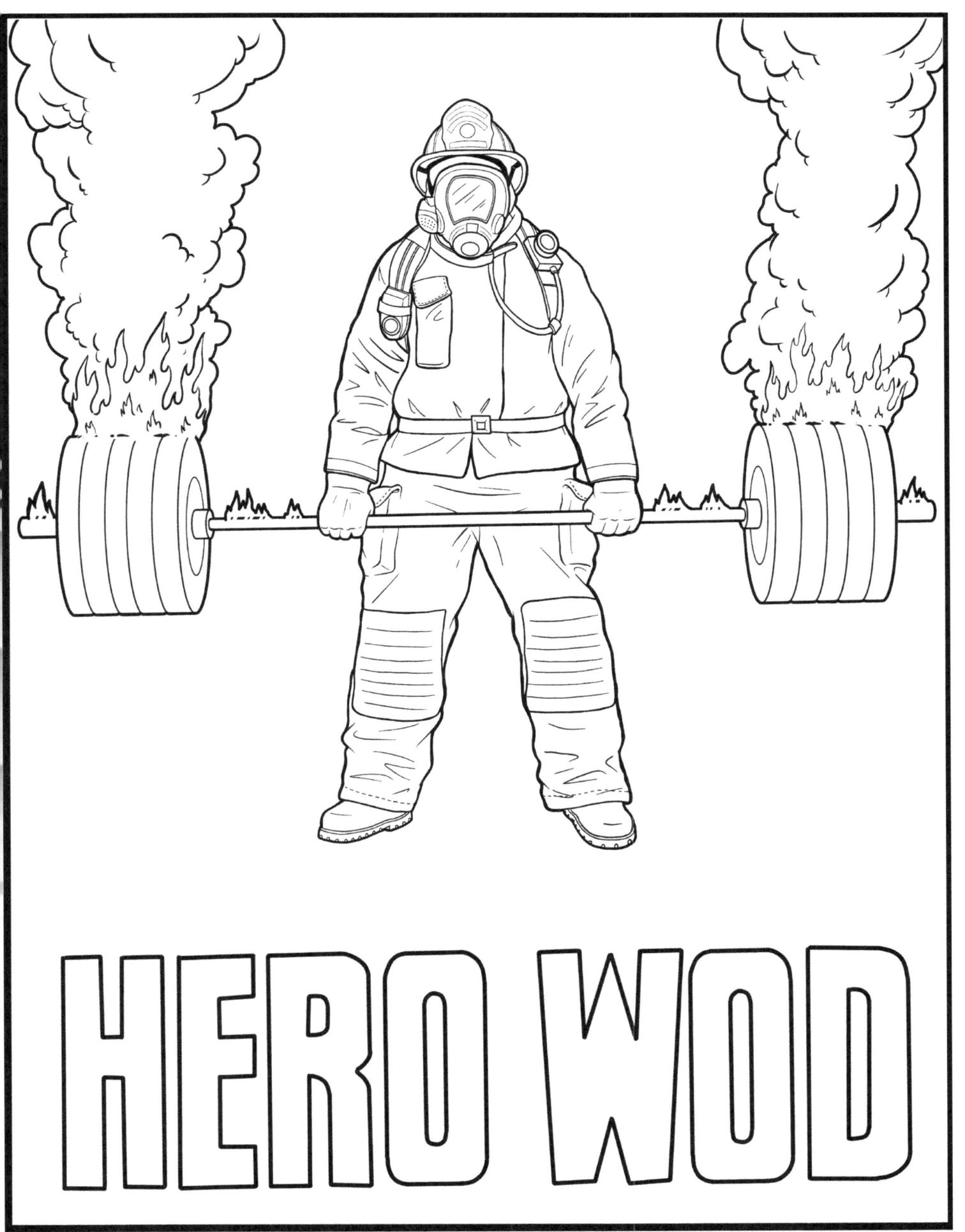

Copyrights 2019 Keith Stone. All artwork is property of the author and may not be reused or duplicated without express written permission from the owner

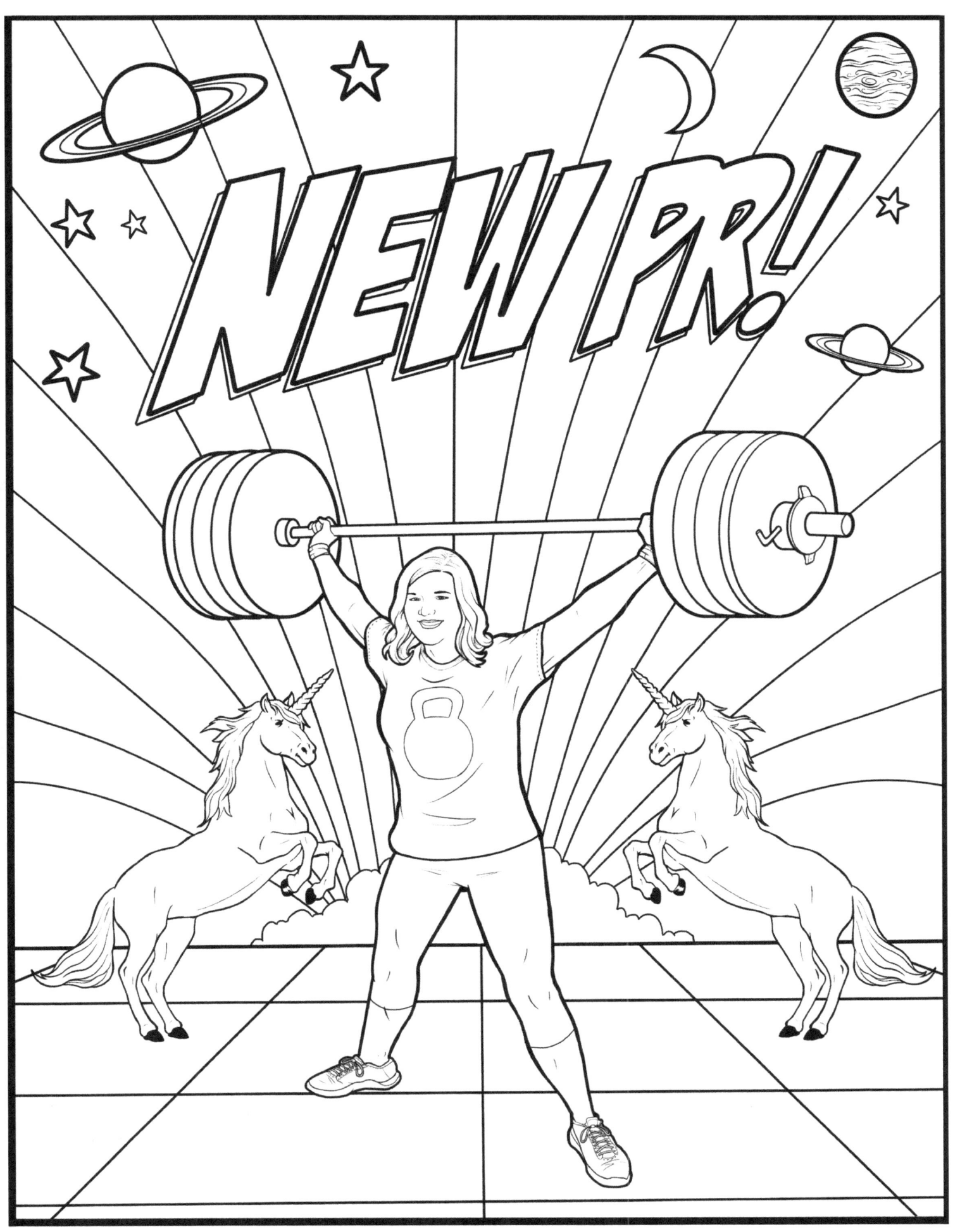

Copyrights 2019 Keith Stone. All artwork is property of the author and may not be reused or duplicated without express written permission from the owner

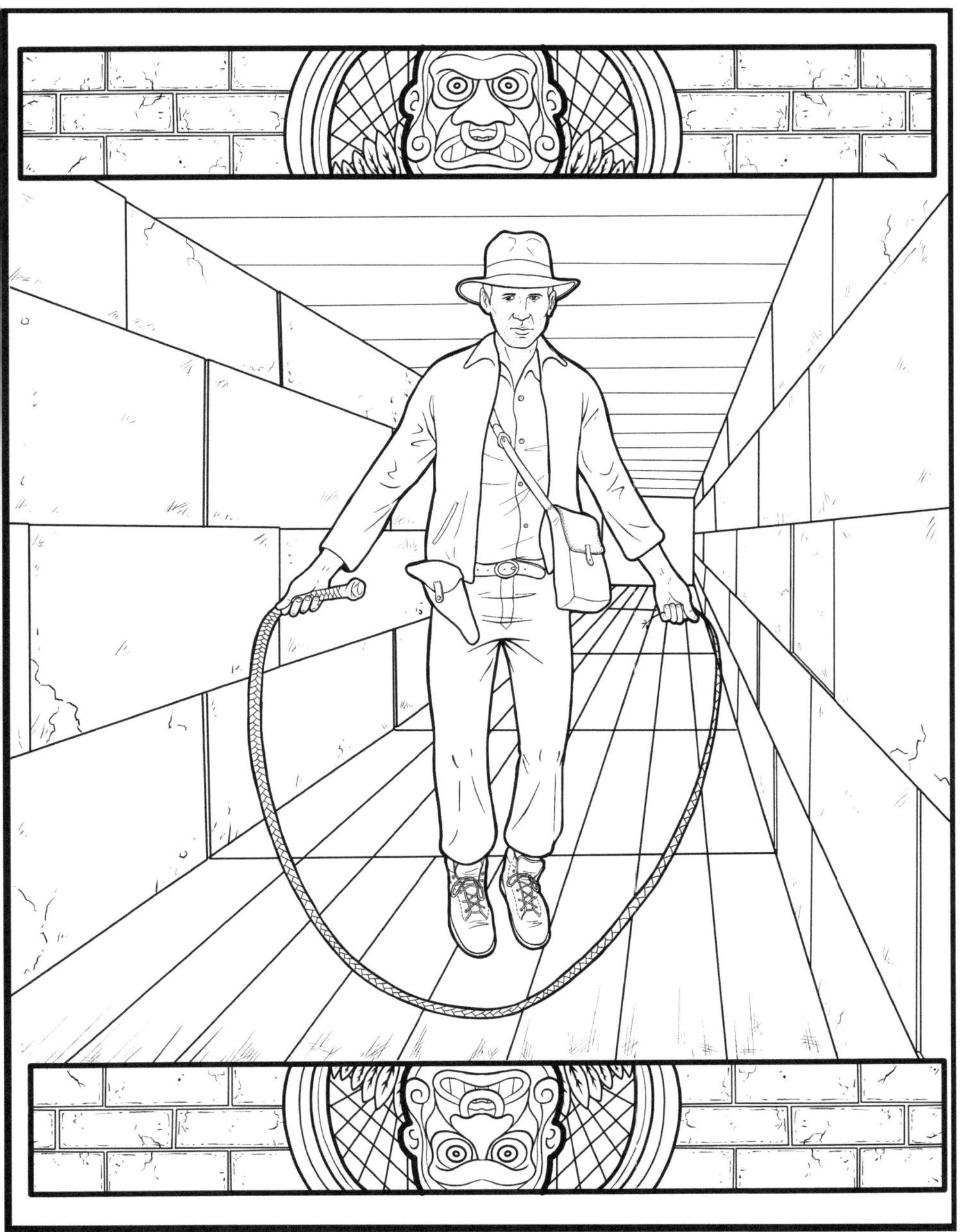

Copyrights 2019 Keith Stone. All artwork is property of the author and may not be reused or duplicated without express written permission from the owner

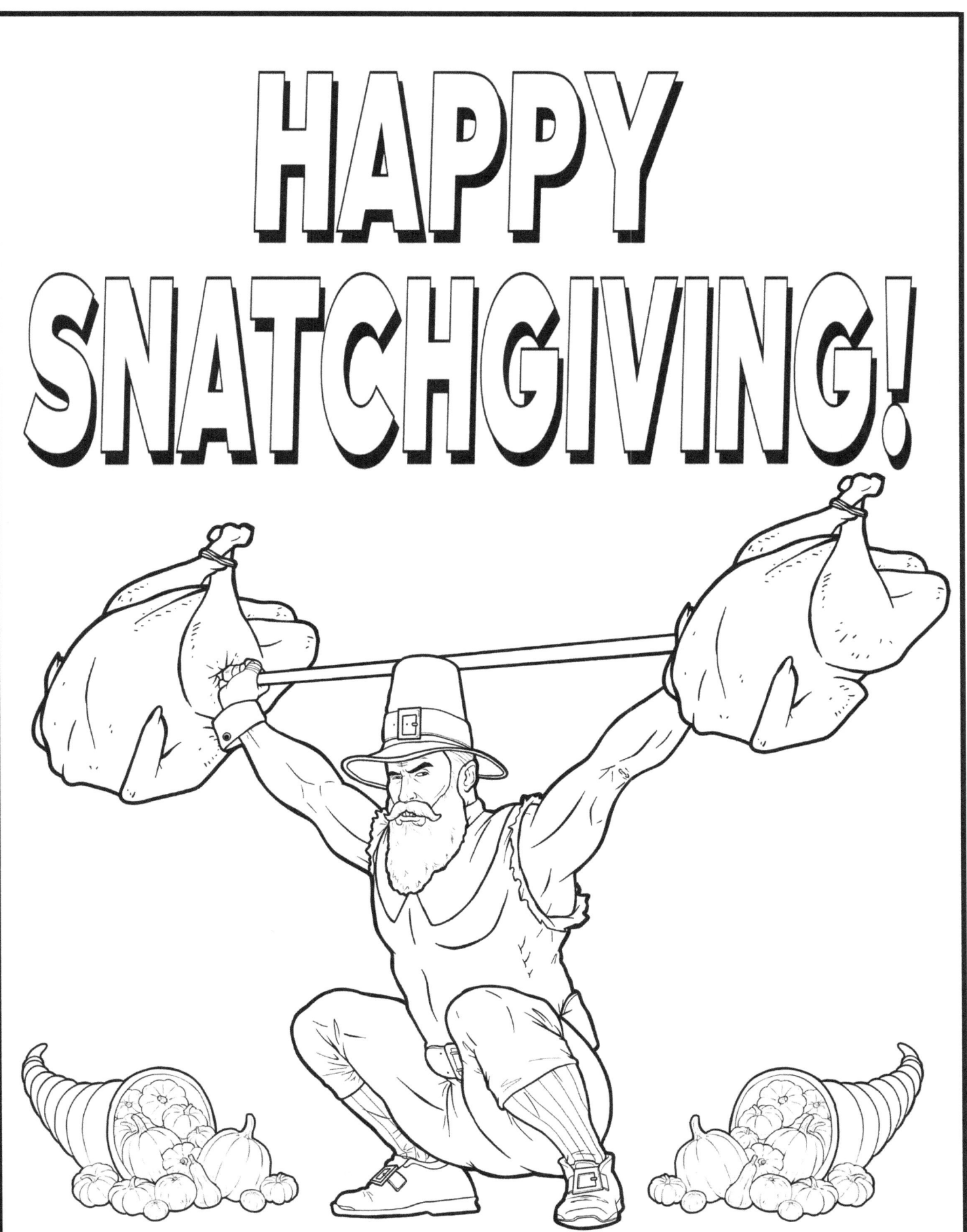

Copyrights 2019 Keith Stone. All artwork is property of the author and may not be reused or duplicated without express written permission from the owner

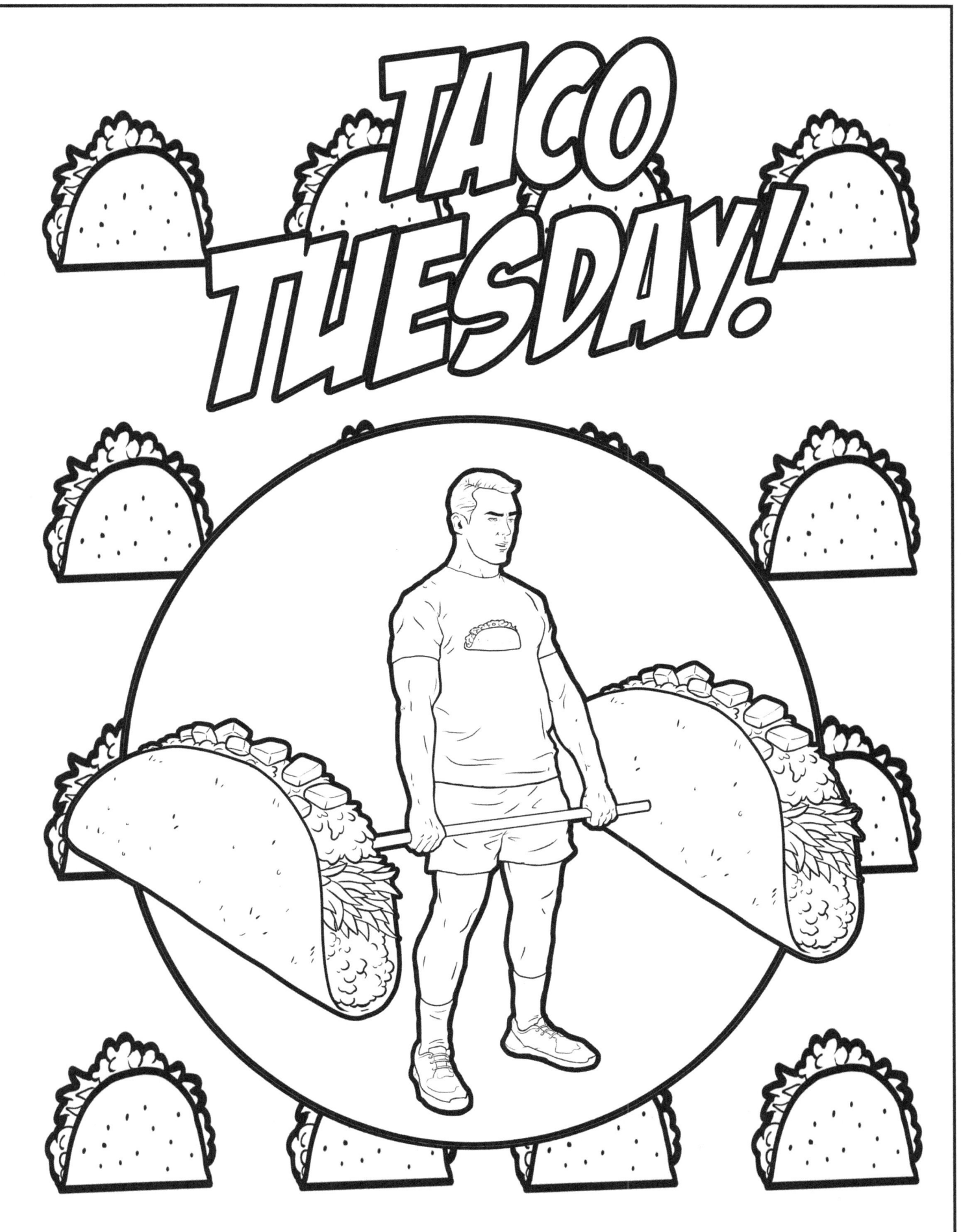

Copyrights 2019 Keith Stone. All artwork is property of the author and may not be reused or duplicated without express written permission from the owner

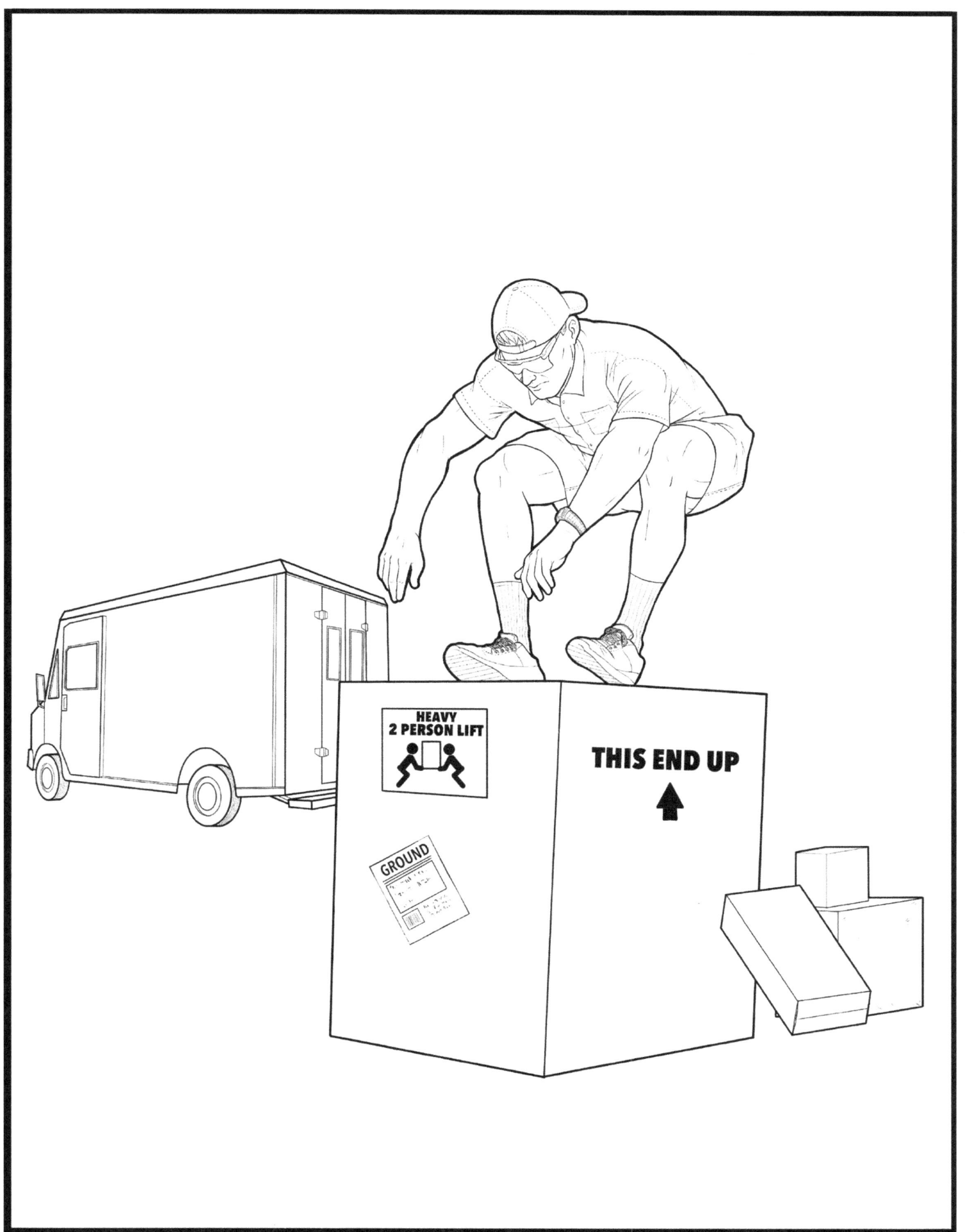

Copyrights 2019 Keith Stone. All artwork is property of the author and may not be reused or duplicated without express written permission from the owner

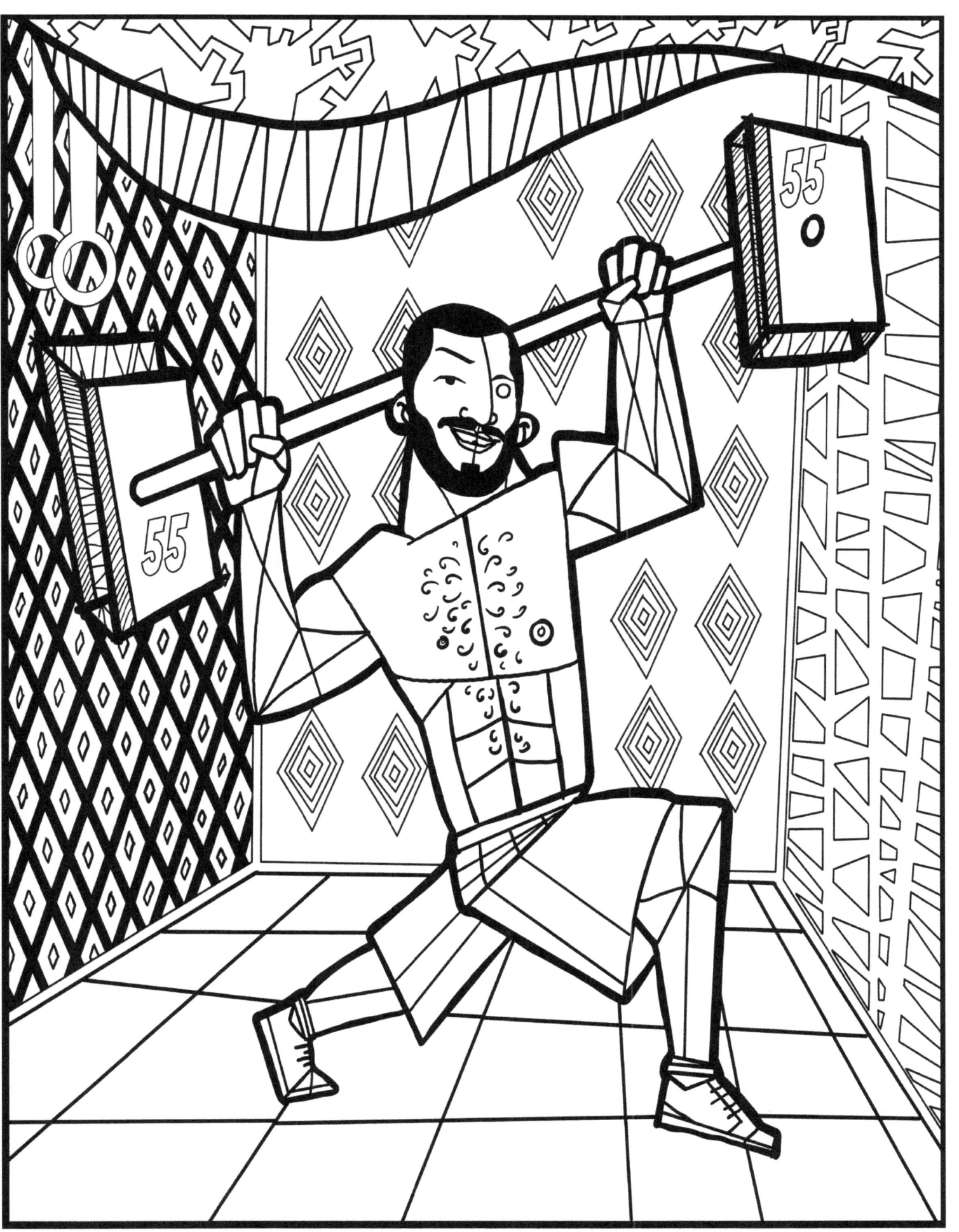

Copyrights 2019 Keith Stone. All artwork is property of the author and may not be reused or duplicated without express written permission from the owner

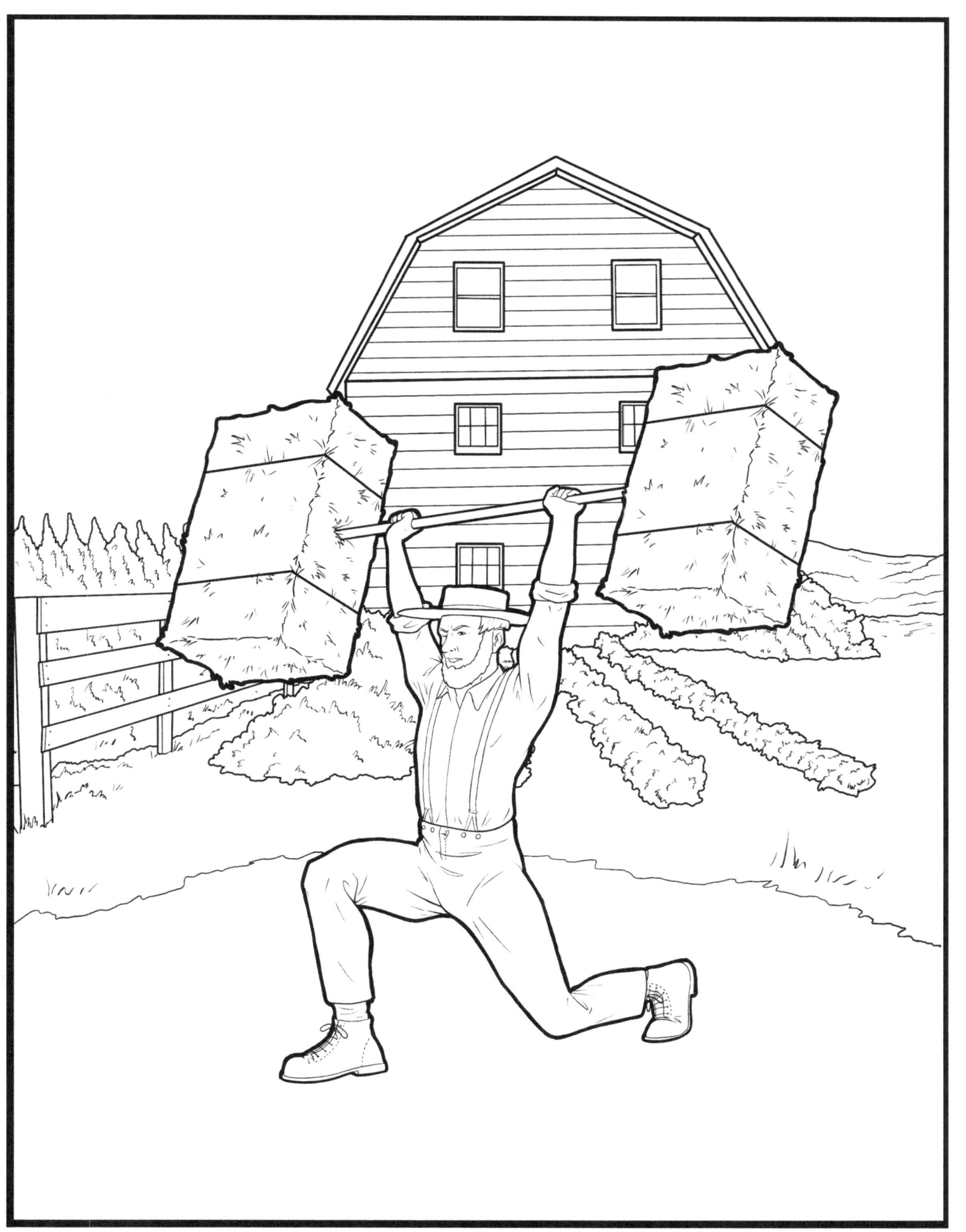

Copyrights 2019 Keith Stone. All artwork is property of the author and may not be reused or duplicated without express written permission from the owner

www.ingramcontent.com/pod-product-compliance
Lightning Source LLC
Chambersburg PA
CBHW081657220526
45466CB00009B/2784